HISTORY OF WESTERN ART IN COMICS

From **Prehistory** to the **Renaissance**

Marion Augustin

Bruno Heitz

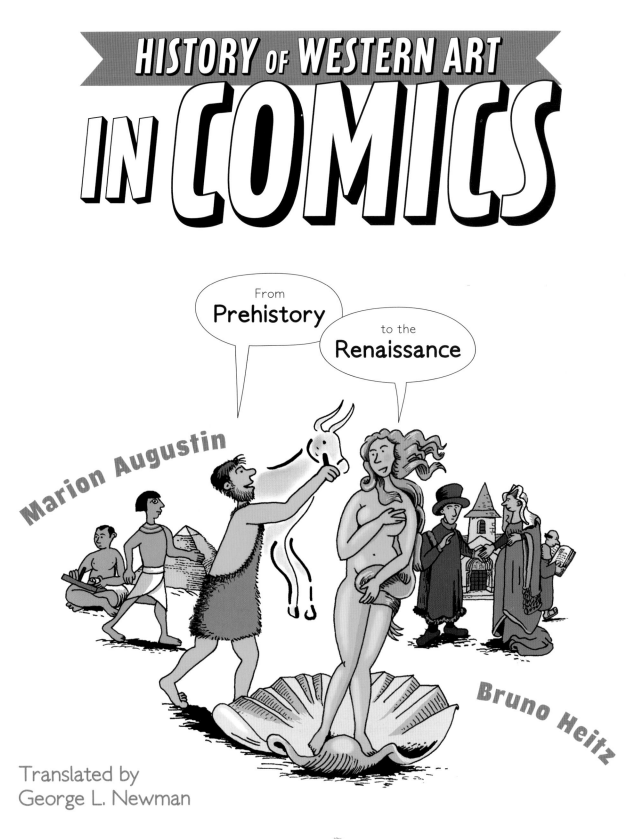

Translated by
George L. Newman

HOLIDAY HOUSE · NEW YORK

To Pablo, Émile, and Noé
—M. A.

First published in French by Editions Casterman s.a, as L'HISTOIRE DE L'ART EN BD T1. DE
LA PREHISTOIRE A LA RENAISSANCE BY MARION AUGUSTIN & BRUNO HEITZ
Copyright © Casterman / 2016
English translation by George L. Newman
English translation copyright © 2021 by Holiday House Publishing, Inc.
All Rights Reserved
HOLIDAY HOUSE is registered in the U.S. Patent and Trademark Office.
Printed and bound in May 2021 at Toppan Leefung, DongGuan, China.
www.holidayhouse.com
First Edition
1 3 5 7 9 10 8 6 4 2

Library of Congress Cataloging-in-Publication Data

Names: Augustin, Marion, author. | Heitz, Bruno, illustrator. | Newman, George L.,
translator. | Augustin, Marion. Histoire de l'art en BD.
Title: The history of western art in comics : from prehistory . . . to the Renaissance! / Marion
Augustin, Bruno Heitz ; English translation by George L. Newman.
Other titles: Histoire de l'art en BD. Engish
Description: New York : Holiday House, [2021]
Audience: Ages 10-Up | Audience: Grades 7–9
Summary: "As two kids give their grandpa a tour of Paris, he starts an
interesting conversation with them—about where all the art they see in their
lives started"— Provided by publisher.
Identifiers: LCCN 2020036268 | ISBN 9780823446452 (hardcover)
ISBN 9780823446469 (paperback)
Subjects: LCSH: Art—History—Juvenile literature. | Art—History—Comic books, strips, etc.
Classification: LCC N5308 .A9413 2021 | DDC 700.9—dc23
LC record available at https://lccn.loc.gov/2020036268

ISBN: 978-0-8234-4645-2 (hardcover)
ISBN: 978-0-8234-4646-9 (paperback)

Art is everywhere in our lives: in the shapes of houses and monuments, on posters glued to walls, in films. But where did it come from? Why have people felt the need to produce works of art? What art forms have people created during their long history? Using what media? What techniques? How have artworks been passed from one civilization to another? What value do we place on them? Why have some been preserved and others forgotten?

This first volume traces the main links between artistic movements in the West from prehistory to the Renaissance. It is primarily devoted to the visual arts: painting, sculpture, and architecture.

Turn the page to relive the fabulous history of art through the ages—treasures of the imagination, marvels of creativity, surprises and thrills await!

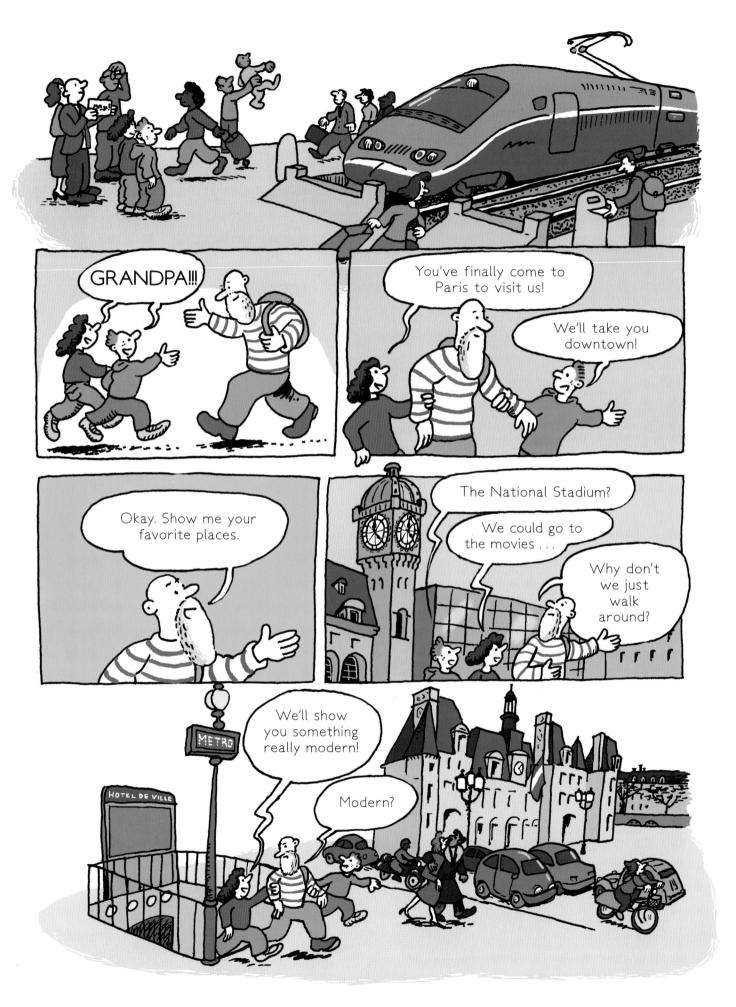

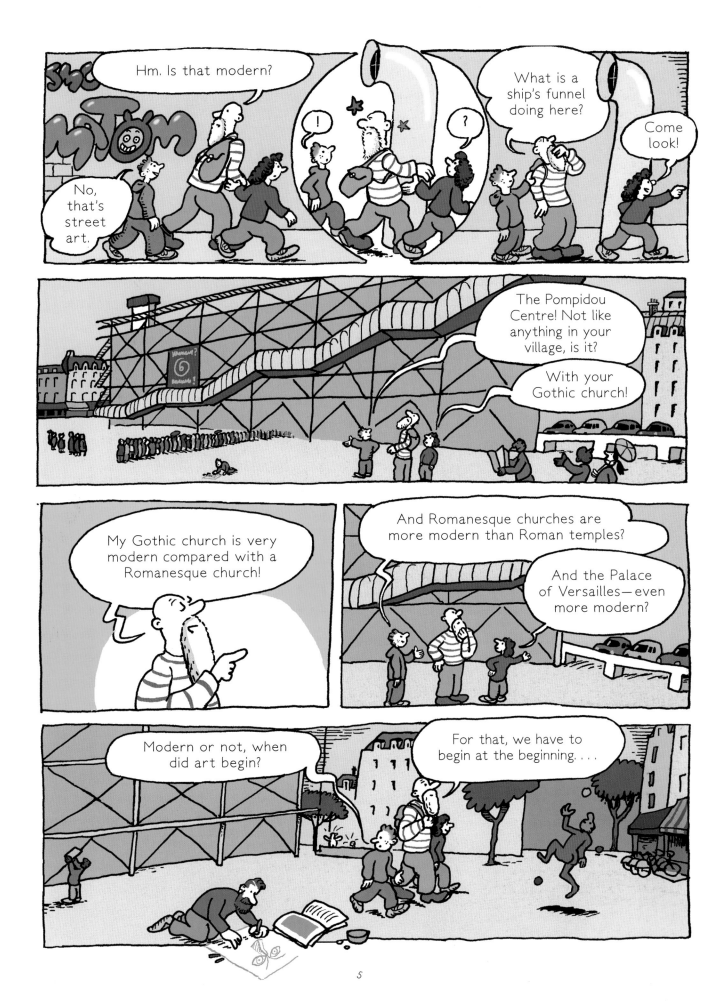

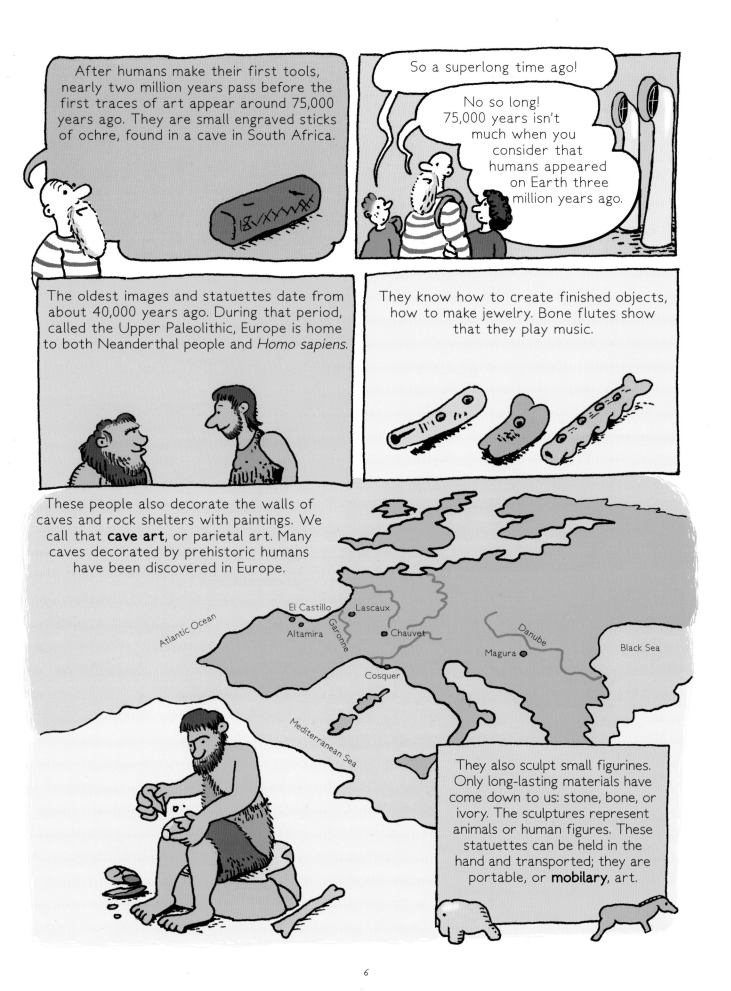

After humans make their first tools, nearly two million years pass before the first traces of art appear around 75,000 years ago. They are small engraved sticks of ochre, found in a cave in South Africa.

So a superlong time ago!

No so long! 75,000 years isn't much when you consider that humans appeared on Earth three million years ago.

The oldest images and statuettes date from about 40,000 years ago. During that period, called the Upper Paleolithic, Europe is home to both Neanderthal people and *Homo sapiens*.

They know how to create finished objects, how to make jewelry. Bone flutes show that they play music.

These people also decorate the walls of caves and rock shelters with paintings. We call that **cave art**, or parietal art. Many caves decorated by prehistoric humans have been discovered in Europe.

Atlantic Ocean

El Castillo
Lascaux
Altamira
Garonne
Chauvet
Danube
Magura
Black Sea
Cosquer
Mediterranean Sea

They also sculpt small figurines. Only long-lasting materials have come down to us: stone, bone, or ivory. The sculptures represent animals or human figures. These statuettes can be held in the hand and transported; they are portable, or **mobilary**, art.

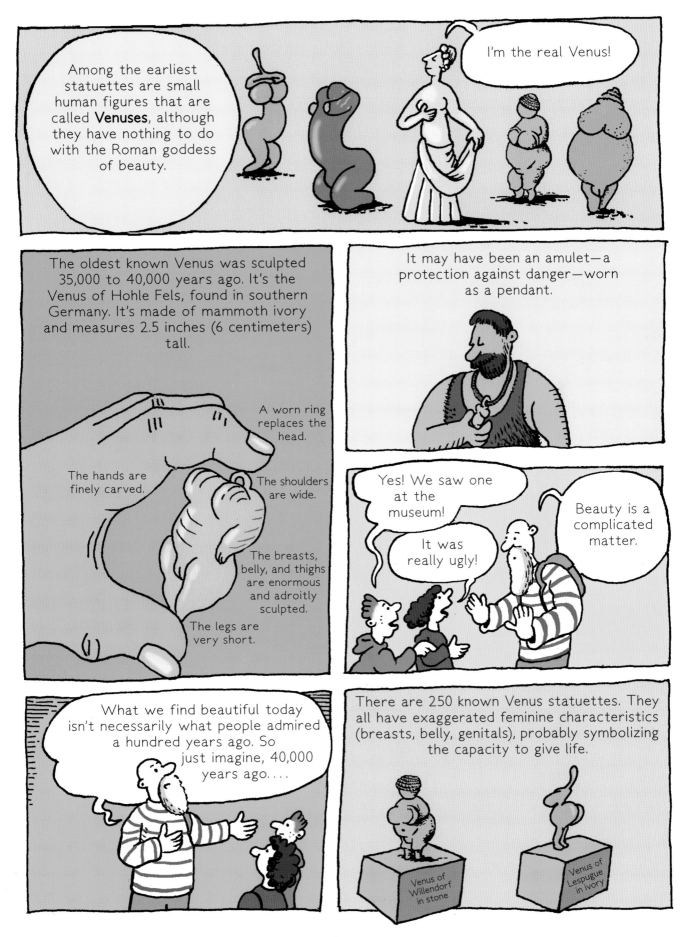

Among the earliest statuettes are small human figures that are called **Venuses**, although they have nothing to do with the Roman goddess of beauty.

I'm the real Venus!

The oldest known Venus was sculpted 35,000 to 40,000 years ago. It's the Venus of Hohle Fels, found in southern Germany. It's made of mammoth ivory and measures 2.5 inches (6 centimeters) tall.

A worn ring replaces the head.

The hands are finely carved.

The shoulders are wide.

The breasts, belly, and thighs are enormous and adroitly sculpted.

The legs are very short.

It may have been an amulet—a protection against danger—worn as a pendant.

Yes! We saw one at the museum!

It was really ugly!

Beauty is a complicated matter.

What we find beautiful today isn't necessarily what people admired a hundred years ago. So just imagine, 40,000 years ago....

There are 250 known Venus statuettes. They all have exaggerated feminine characteristics (breasts, belly, genitals), probably symbolizing the capacity to give life.

Venus of Willendorf in stone

Venus of Lespugue in ivory

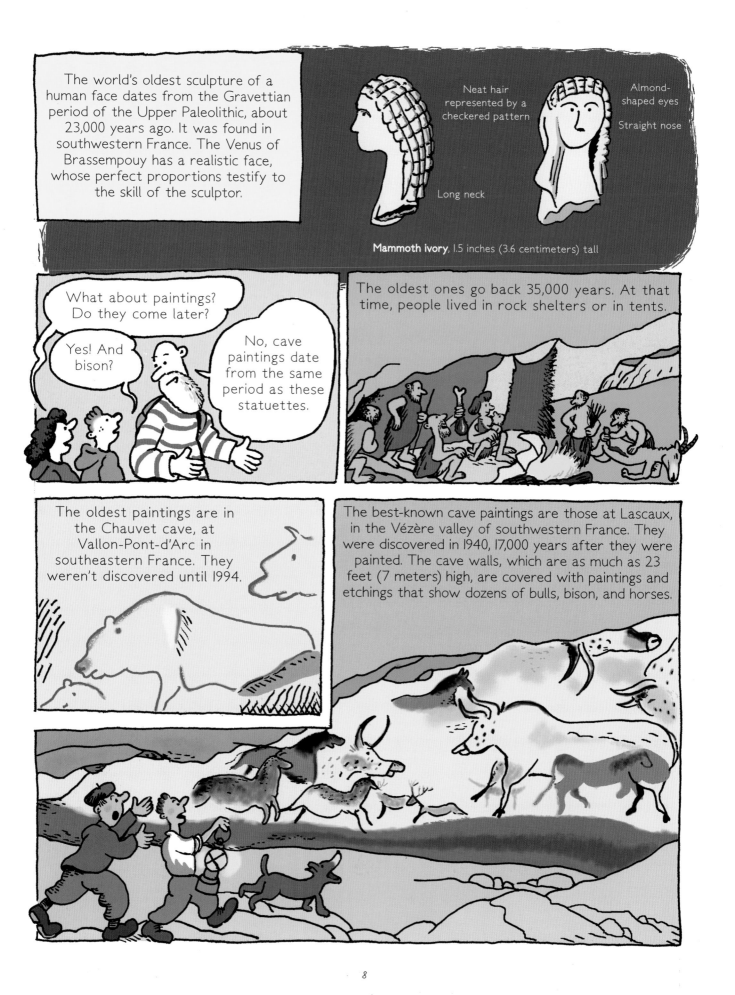

The world's oldest sculpture of a human face dates from the Gravettian period of the Upper Paleolithic, about 23,000 years ago. It was found in southwestern France. The Venus of Brassempouy has a realistic face, whose perfect proportions testify to the skill of the sculptor.

Neat hair represented by a checkered pattern

Long neck

Almond-shaped eyes

Straight nose

Mammoth ivory, 1.5 inches (3.6 centimeters) tall

What about paintings? Do they come later?

Yes! And bison?

No, cave paintings date from the same period as these statuettes.

The oldest ones go back 35,000 years. At that time, people lived in rock shelters or in tents.

The oldest paintings are in the Chauvet cave, at Vallon-Pont-d'Arc in southeastern France. They weren't discovered until 1994.

The best-known cave paintings are those at Lascaux, in the Vézère valley of southwestern France. They were discovered in 1940, 17,000 years after they were painted. The cave walls, which are as much as 23 feet (7 meters) high, are covered with paintings and etchings that show dozens of bulls, bison, and horses.

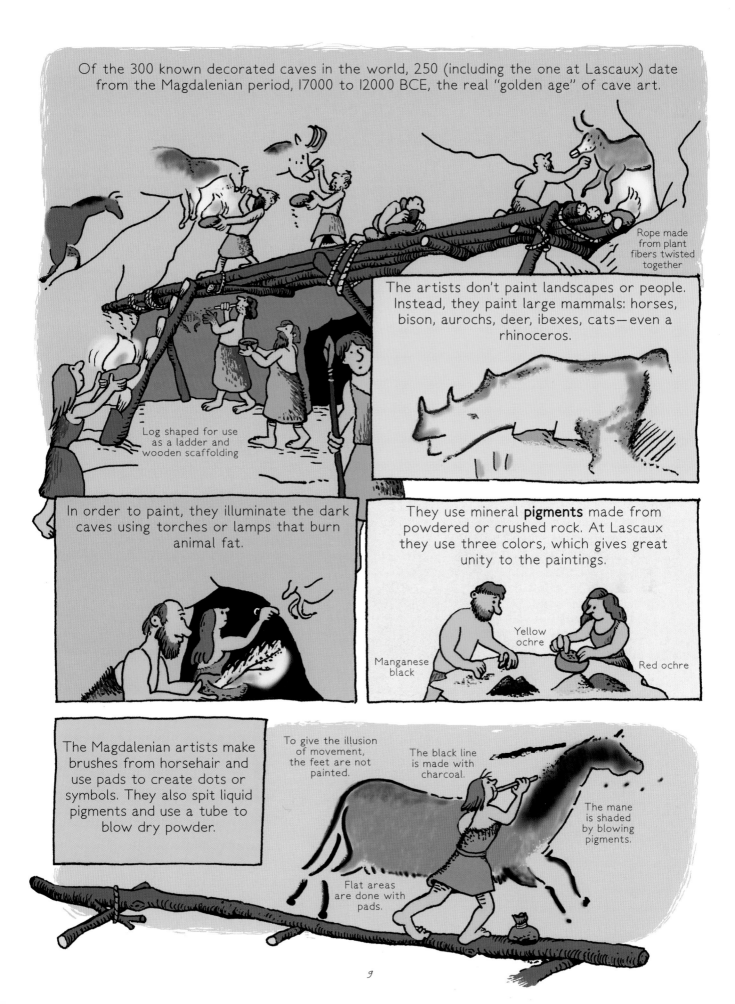

Of the 300 known decorated caves in the world, 250 (including the one at Lascaux) date from the Magdalenian period, 17000 to 12000 BCE, the real "golden age" of cave art.

Rope made from plant fibers twisted together

Log shaped for use as a ladder and wooden scaffolding

The artists don't paint landscapes or people. Instead, they paint large mammals: horses, bison, aurochs, deer, ibexes, cats—even a rhinoceros.

In order to paint, they illuminate the dark caves using torches or lamps that burn animal fat.

They use mineral **pigments** made from powdered or crushed rock. At Lascaux they use three colors, which gives great unity to the paintings.

Manganese black

Yellow ochre

Red ochre

The Magdalenian artists make brushes from horsehair and use pads to create dots or symbols. They also spit liquid pigments and use a tube to blow dry powder.

To give the illusion of movement, the feet are not painted.

The black line is made with charcoal.

The mane is shaded by blowing pigments.

Flat areas are done with pads.

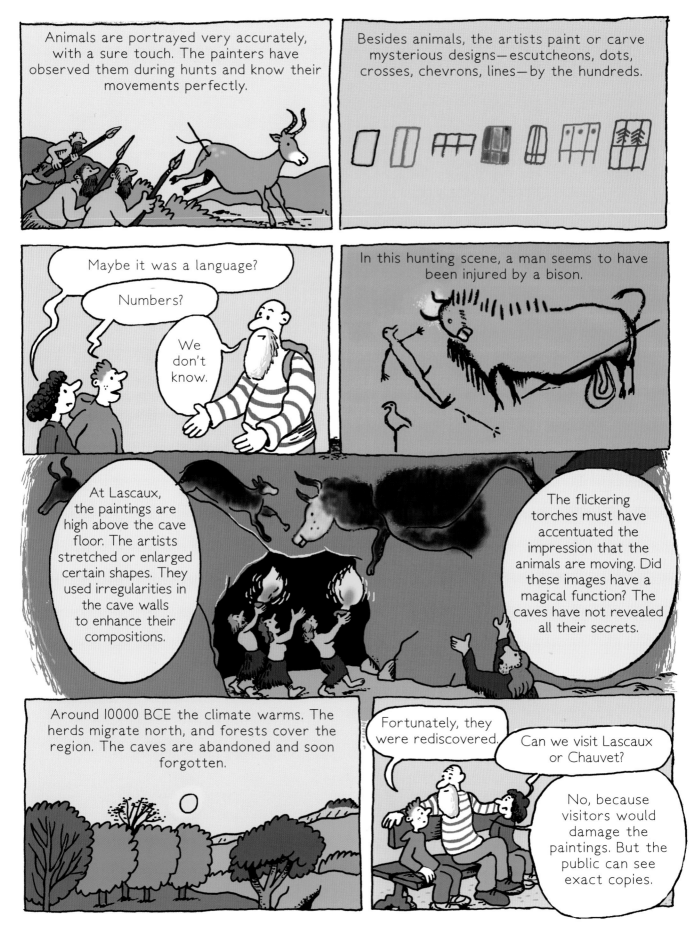

Animals are portrayed very accurately, with a sure touch. The painters have observed them during hunts and know their movements perfectly.

Besides animals, the artists paint or carve mysterious designs—escutcheons, dots, crosses, chevrons, lines—by the hundreds.

Maybe it was a language?

Numbers?

We don't know.

In this hunting scene, a man seems to have been injured by a bison.

At Lascaux, the paintings are high above the cave floor. The artists stretched or enlarged certain shapes. They used irregularities in the cave walls to enhance their compositions.

The flickering torches must have accentuated the impression that the animals are moving. Did these images have a magical function? The caves have not revealed all their secrets.

Around 10000 BCE the climate warms. The herds migrate north, and forests cover the region. The caves are abandoned and soon forgotten.

Fortunately, they were rediscovered.

Can we visit Lascaux or Chauvet?

No, because visitors would damage the paintings. But the public can see exact copies.

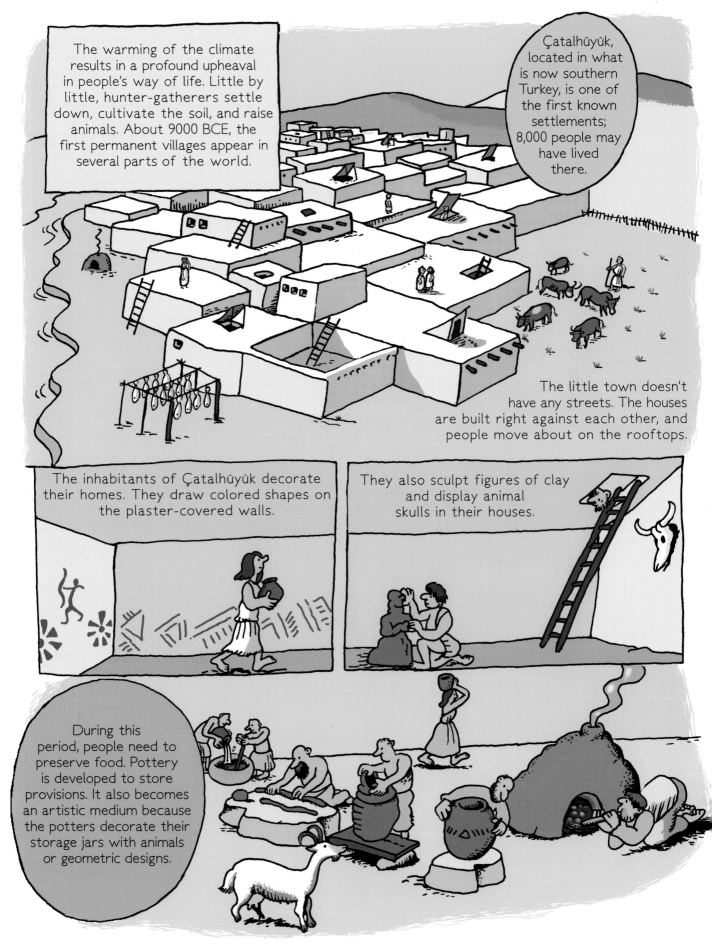

The warming of the climate results in a profound upheaval in people's way of life. Little by little, hunter-gatherers settle down, cultivate the soil, and raise animals. About 9000 BCE, the first permanent villages appear in several parts of the world.

Çatalhüyük, located in what is now southern Turkey, is one of the first known settlements; 8,000 people may have lived there.

The little town doesn't have any streets. The houses are built right against each other, and people move about on the rooftops.

The inhabitants of Çatalhüyük decorate their homes. They draw colored shapes on the plaster-covered walls.

They also sculpt figures of clay and display animal skulls in their houses.

During this period, people need to preserve food. Pottery is developed to store provisions. It also becomes an artistic medium because the potters decorate their storage jars with animals or geometric designs.

At the same time in western Europe, people build imposing constructions of heavy stones, called megaliths.

Right! Menhirs, like in Asterix!

Well, that's a funny comic, but this happened long before the Gauls!

Some megaliths are in lines, like at Carnac in Brittany, where more than 3,000 standing stones extend for around 2.5 miles (4 kilometers).

Other megaliths take the form of shelters (dolmens) or circles (cromlechs). Stonehenge, in southern England, is the most famous grouping of megaliths. The site is exceptional for its size and for the mystery that surrounds it.

In the beginning, about 2800 BCE, a large circle of holes was surrounded by a ditch bordered by an embankment.

Menhirs were erected inside this circle. Their dimensions are impressive.

Stonehenge site

Stonehenge is built in several stages, over the course of several hundred years.

Tools at the time are rudimentary: picks made from deer antlers, shovels from cows' shoulder blades, hammers and axes from flint . . .

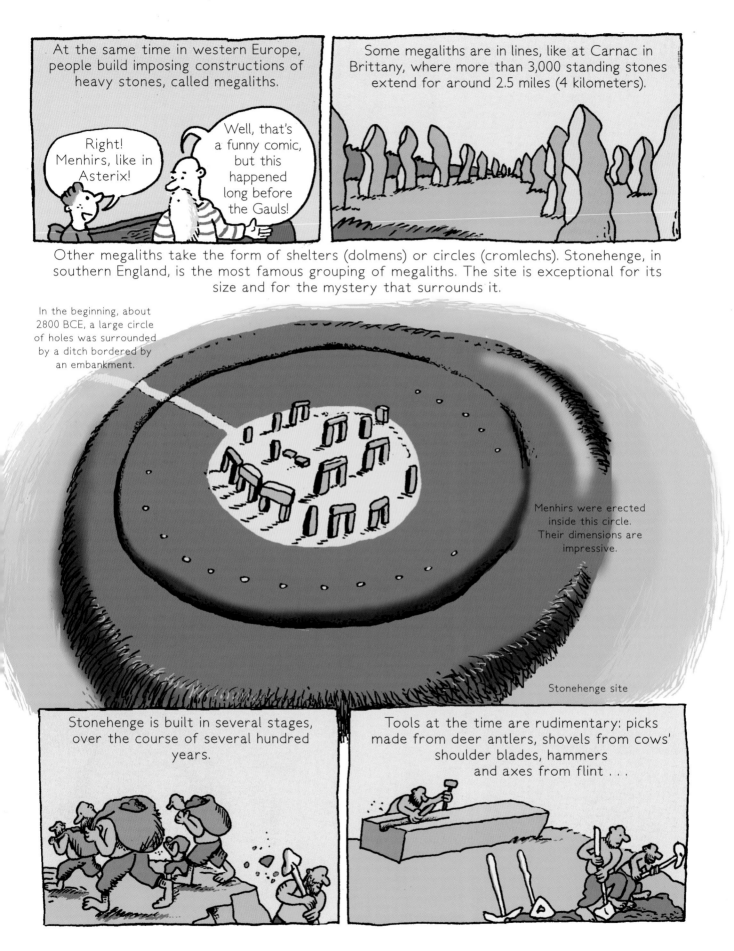

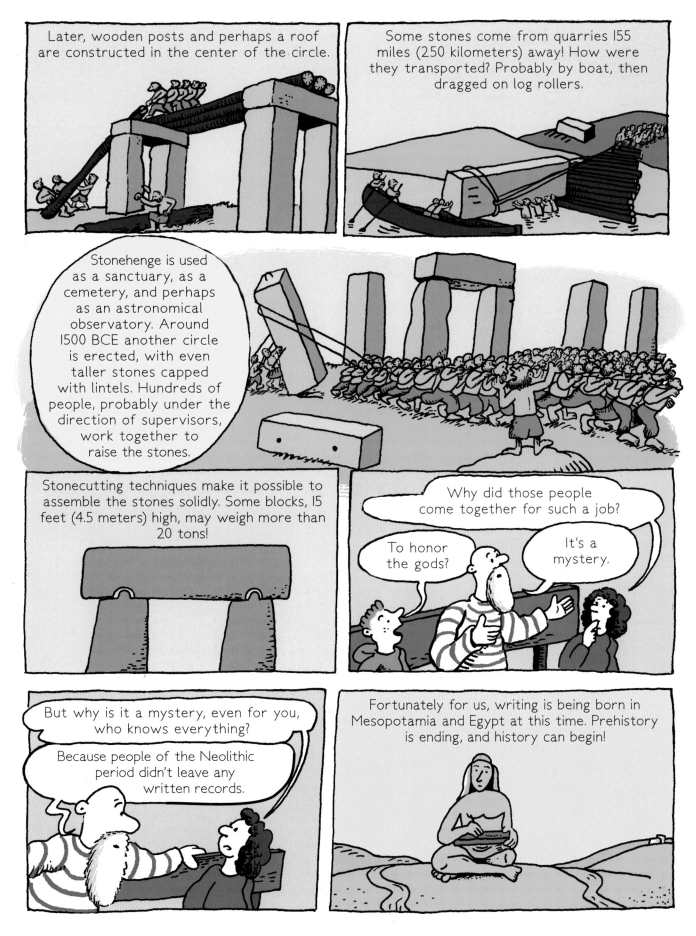

Later, wooden posts and perhaps a roof are constructed in the center of the circle.

Some stones come from quarries 155 miles (250 kilometers) away! How were they transported? Probably by boat, then dragged on log rollers.

Stonehenge is used as a sanctuary, as a cemetery, and perhaps as an astronomical observatory. Around 1500 BCE another circle is erected, with even taller stones capped with lintels. Hundreds of people, probably under the direction of supervisors, work together to raise the stones.

Stonecutting techniques make it possible to assemble the stones solidly. Some blocks, 15 feet (4.5 meters) high, may weigh more than 20 tons!

Why did those people come together for such a job?

To honor the gods?

It's a mystery.

But why is it a mystery, even for you, who knows everything?

Because people of the Neolithic period didn't leave any written records.

Fortunately for us, writing is being born in Mesopotamia and Egypt at this time. Prehistory is ending, and history can begin!

Time Line of Antiquity

About 3300 BCE	Birth of writing in Mesopotamia
About 3200–1100 BCE	Cycladic civilization
About 3000–1100 BCE	Minoan civilization
2560 BCE	Pyramid of Khufu
1792–1750 BCE	Reign of Hammurabi in Babylon
About 1600–1100 BCE	Mycenaean civilization
About 1350 BCE	Reign of Tutankhamen
8th century BCE	Homer recounts the *Iliad* and the *Odyssey*
776 BCE	First Olympic Games
753 BCE	According to legend, Rome is founded by Romulus
509 BCE	Beginning of the Roman Republic
5th century BCE	Pericles governs Athens, the leading city of Greece
About 440 BCE	Phidias supervises the sculpting of the Parthenon's friezes

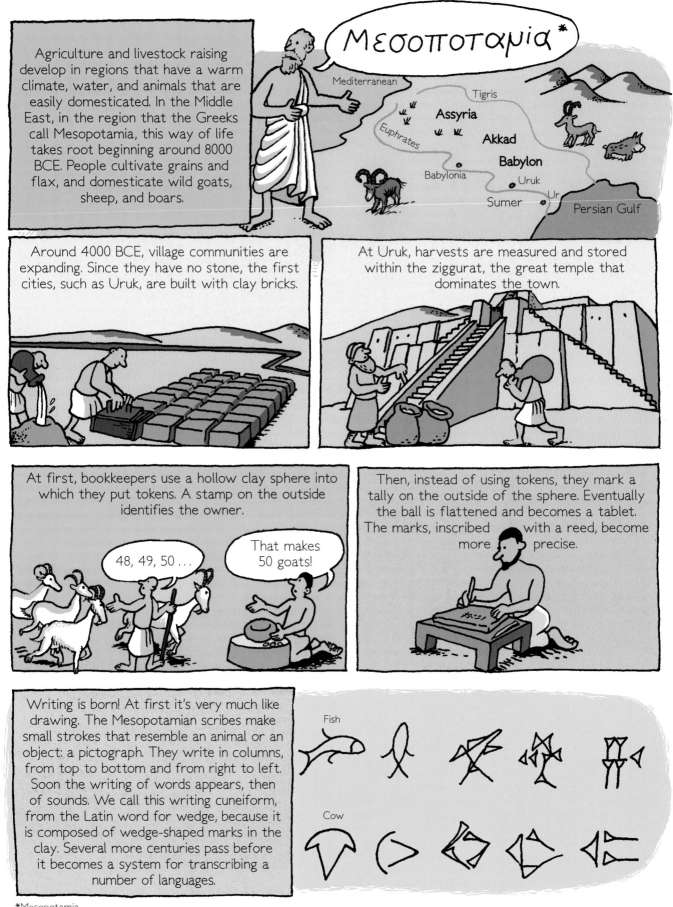

Agriculture and livestock raising develop in regions that have a warm climate, water, and animals that are easily domesticated. In the Middle East, in the region that the Greeks call Mesopotamia, this way of life takes root beginning around 8000 BCE. People cultivate grains and flax, and domesticate wild goats, sheep, and boars.

Μεσοποταμία*

Mediterranean
Tigris
Assyria
Euphrates
Akkad
Babylon
Babylonia
Uruk
Sumer
Ur
Persian Gulf

Around 4000 BCE, village communities are expanding. Since they have no stone, the first cities, such as Uruk, are built with clay bricks.

At Uruk, harvests are measured and stored within the ziggurat, the great temple that dominates the town.

At first, bookkeepers use a hollow clay sphere into which they put tokens. A stamp on the outside identifies the owner.

48, 49, 50 . . .

That makes 50 goats!

Then, instead of using tokens, they mark a tally on the outside of the sphere. Eventually the ball is flattened and becomes a tablet. The marks, inscribed with a reed, become more precise.

Writing is born! At first it's very much like drawing. The Mesopotamian scribes make small strokes that resemble an animal or an object: a pictograph. They write in columns, from top to bottom and from right to left. Soon the writing of words appears, then of sounds. We call this writing cuneiform, from the Latin word for wedge, because it is composed of wedge-shaped marks in the clay. Several more centuries pass before it becomes a system for transcribing a number of languages.

Fish

Cow

*Mesopotamia

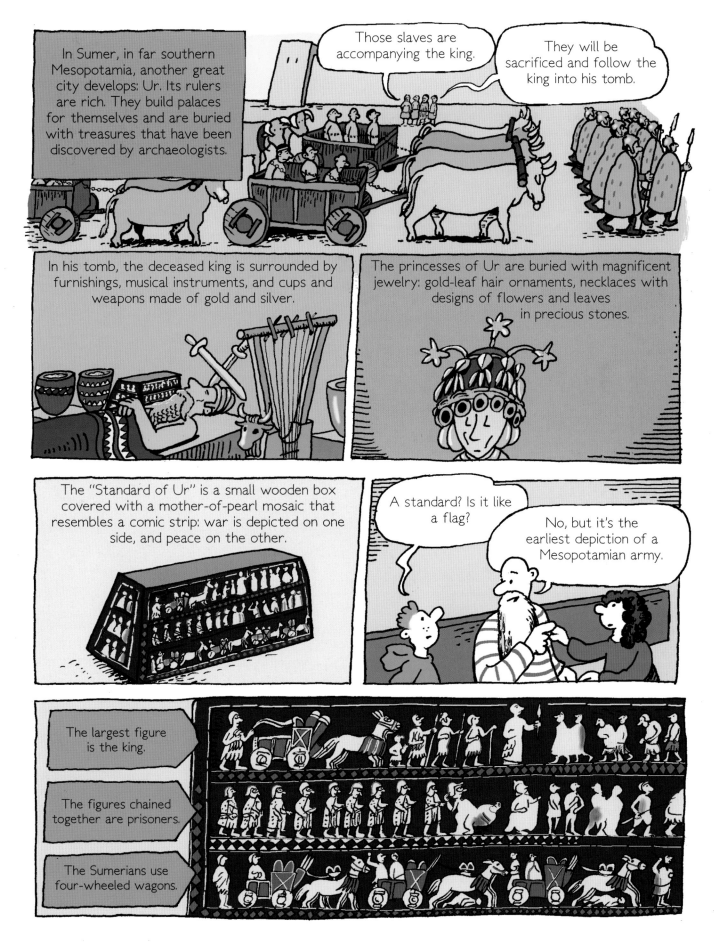

In Sumer, in far southern Mesopotamia, another great city develops: Ur. Its rulers are rich. They build palaces for themselves and are buried with treasures that have been discovered by archaeologists.

Those slaves are accompanying the king.

They will be sacrificed and follow the king into his tomb.

In his tomb, the deceased king is surrounded by furnishings, musical instruments, and cups and weapons made of gold and silver.

The princesses of Ur are buried with magnificent jewelry: gold-leaf hair ornaments, necklaces with designs of flowers and leaves in precious stones.

The "Standard of Ur" is a small wooden box covered with a mother-of-pearl mosaic that resembles a comic strip: war is depicted on one side, and peace on the other.

A standard? Is it like a flag?

No, but it's the earliest depiction of a Mesopotamian army.

The largest figure is the king.

The figures chained together are prisoners.

The Sumerians use four-wheeled wagons.

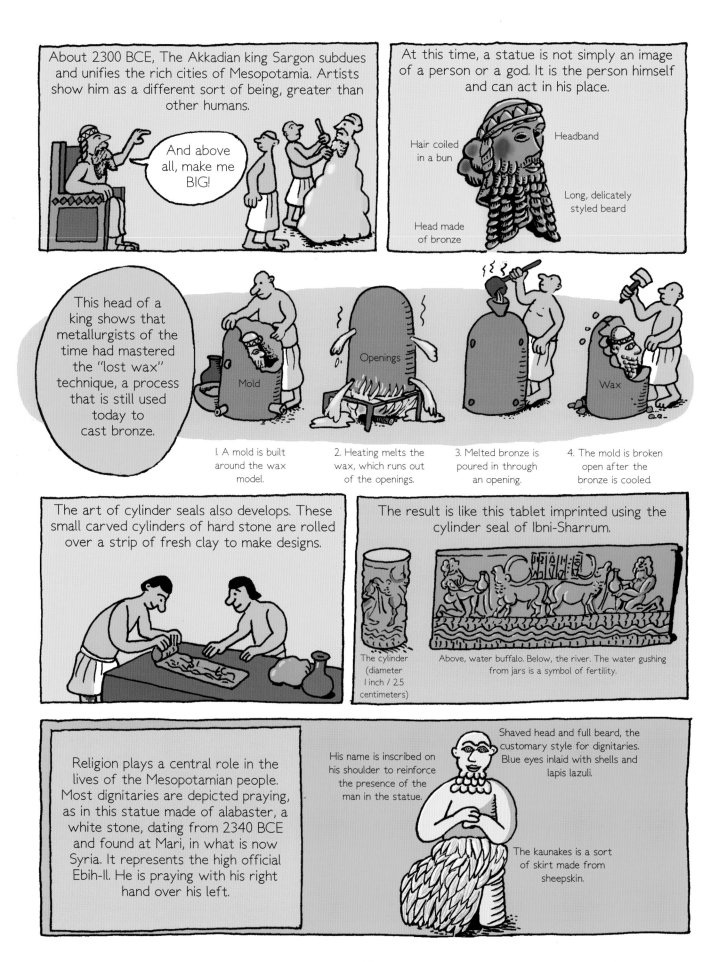

About 2300 BCE, The Akkadian king Sargon subdues and unifies the rich cities of Mesopotamia. Artists show him as a different sort of being, greater than other humans.

And above all, make me BIG!

At this time, a statue is not simply an image of a person or a god. It is the person himself and can act in his place.

Hair coiled in a bun

Headband

Long, delicately styled beard

Head made of bronze

This head of a king shows that metallurgists of the time had mastered the "lost wax" technique, a process that is still used today to cast bronze.

Mold

Openings

Wax

1. A mold is built around the wax model.

2. Heating melts the wax, which runs out of the openings.

3. Melted bronze is poured in through an opening.

4. The mold is broken open after the bronze is cooled.

The art of cylinder seals also develops. These small carved cylinders of hard stone are rolled over a strip of fresh clay to make designs.

The result is like this tablet imprinted using the cylinder seal of Ibni-Sharrum.

The cylinder (diameter 1 inch / 2.5 centimeters)

Above, water buffalo. Below, the river. The water gushing from jars is a symbol of fertility.

Religion plays a central role in the lives of the Mesopotamian people. Most dignitaries are depicted praying, as in this statue made of alabaster, a white stone, dating from 2340 BCE and found at Mari, in what is now Syria. It represents the high official Ebih-Il. He is praying with his right hand over his left.

His name is inscribed on his shoulder to reinforce the presence of the man in the statue.

Shaved head and full beard, the customary style for dignitaries. Blue eyes inlaid with shells and lapis lazuli.

The kaunakes is a sort of skirt made from sheepskin.

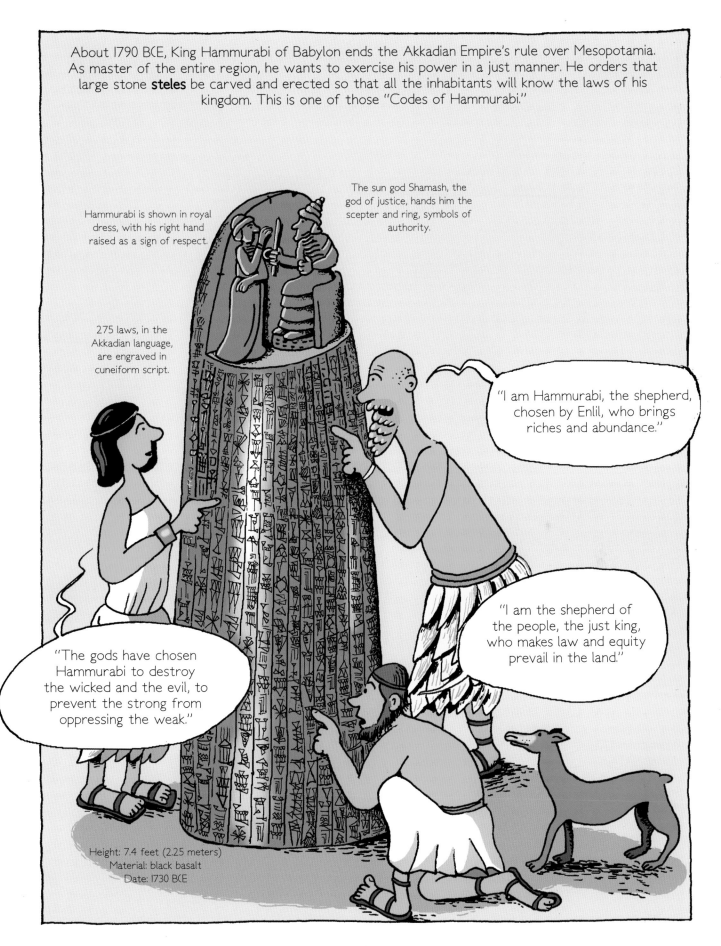

About 1790 BCE, King Hammurabi of Babylon ends the Akkadian Empire's rule over Mesopotamia. As master of the entire region, he wants to exercise his power in a just manner. He orders that large stone **steles** be carved and erected so that all the inhabitants will know the laws of his kingdom. This is one of those "Codes of Hammurabi."

Hammurabi is shown in royal dress, with his right hand raised as a sign of respect.

The sun god Shamash, the god of justice, hands him the scepter and ring, symbols of authority.

275 laws, in the Akkadian language, are engraved in cuneiform script.

"I am Hammurabi, the shepherd, chosen by Enlil, who brings riches and abundance."

"I am the shepherd of the people, the just king, who makes law and equity prevail in the land."

"The gods have chosen Hammurabi to destroy the wicked and the evil, to prevent the strong from oppressing the weak."

Height: 7.4 feet (2.25 meters)
Material: black basalt
Date: 1730 BCE

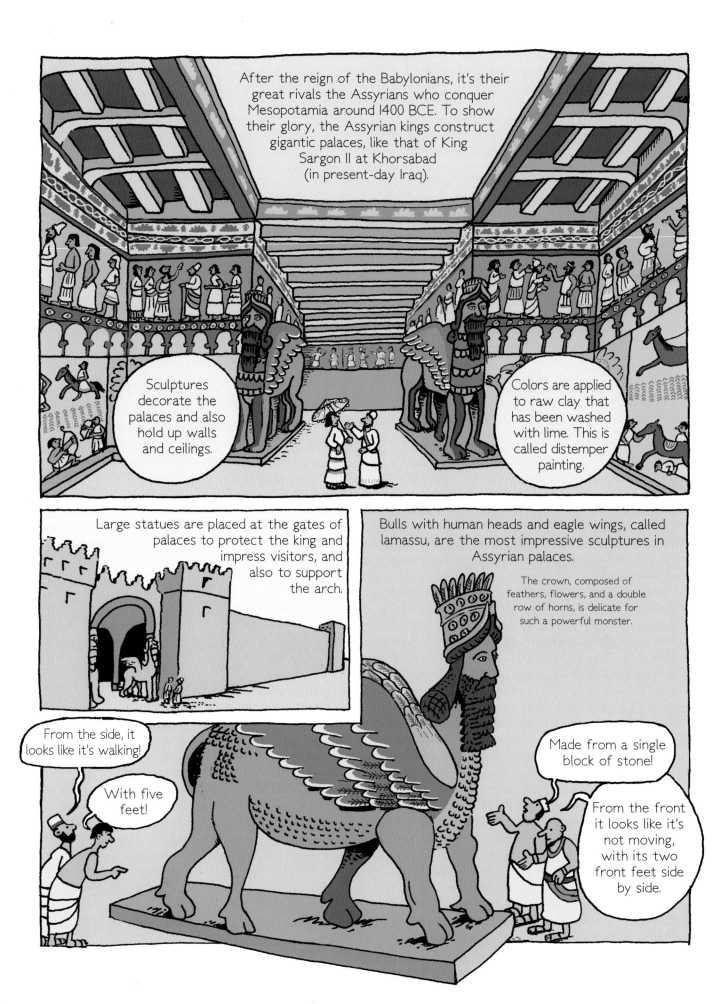

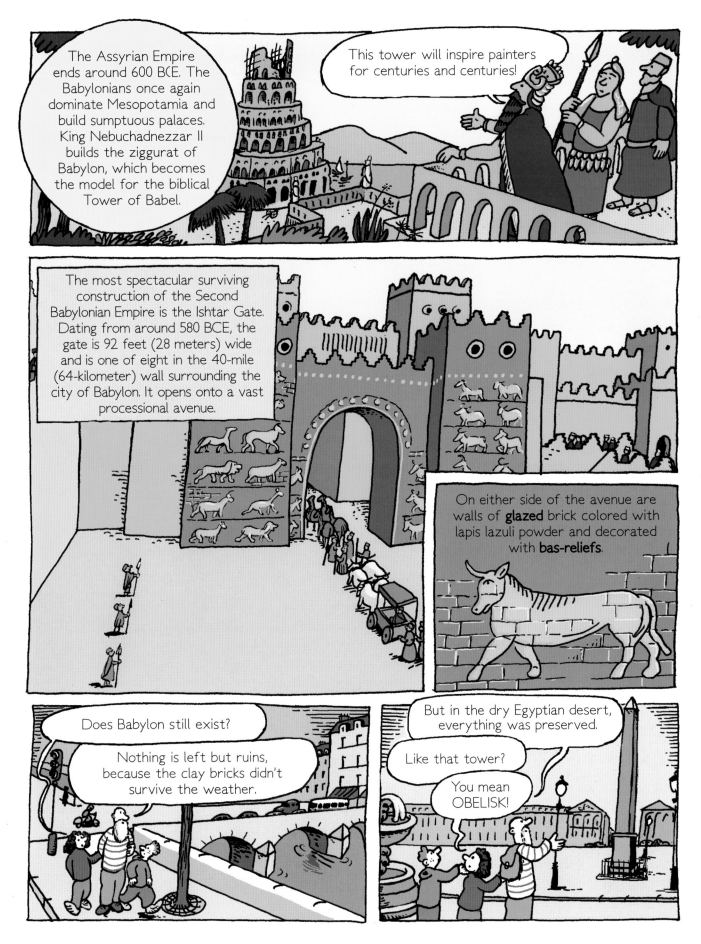

The Assyrian Empire ends around 600 BCE. The Babylonians once again dominate Mesopotamia and build sumptuous palaces. King Nebuchadnezzar II builds the ziggurat of Babylon, which becomes the model for the biblical Tower of Babel.

This tower will inspire painters for centuries and centuries!

The most spectacular surviving construction of the Second Babylonian Empire is the Ishtar Gate. Dating from around 580 BCE, the gate is 92 feet (28 meters) wide and is one of eight in the 40-mile (64-kilometer) wall surrounding the city of Babylon. It opens onto a vast processional avenue.

On either side of the avenue are walls of **glazed** brick colored with lapis lazuli powder and decorated with **bas-reliefs**.

Does Babylon still exist?

Nothing is left but ruins, because the clay bricks didn't survive the weather.

But in the dry Egyptian desert, everything was preserved.

Like that tower?

You mean OBELISK!

About 3000 BCE, at the same time writing is being born in Mesopotamia, a civilization develops that will last for nearly thirty centuries: ancient Egypt. It flourishes on the fertile soil of the Nile Valley, beyond which extends a vast, inhospitable desert.

The country is unified around 3000 BCE. This stone palette, carved on both sides, celebrates the victory of the country's South over the North.

King Narmer, wearing the crown of Upper Egypt, clubs a kneeling enemy from the North.

Behind him, a servant carries his sandals.

The king's name is framed by two faces of the cow-headed goddess Hathor.

Narmer inspects the bodies of his decapitated enemies.

Two lionesses with wildly long necks are held on leashes.

The king, in the form of a bull, destroys the walls of a conquered city.

Palette of Narmer

All the principles of Egyptian design are demonstrated on King Narmer's palette, and each element is immediately recognizable: the king is larger than the others; his enemies are very small; faces and legs are shown in profile, but shoulders are shown from the front.

Yes! They all walked like this!

Most art is linked to religion. The Egyptians believe that the tomb is the dead person's home for eternity. Built of stone, it shelters the mummy so that the deceased can make the journey to the kingdom of the dead, and then continue to live.

The first kings are buried in trapezoid-shaped tombs, called mastabas.

Imhotep, you're an architect. Find a way to make me a tomb that's . . .

bigger and more impressive!

To show his power, the pharaoh Djoser decides to cover his tomb with a tall structure.

I think I have an idea!

After Djoser, about 2600 BCE, the pharaoh Khufu comes to the throne. He begins construction of his tomb, a smooth-faced pyramid, at Giza beside the Nile. Thousands of workers transport, lift, and assemble huge blocks of stone, which arrive by boat. This type of tomb symbolizes Egypt in the eyes of the whole world.

The peak of the pyramid, 480 feet (147 meters) high, is covered with a mixture of gold and silver to help the king find his way to heaven.

Within the pyramid is the chamber where the king is buried.

Two million blocks are needed to build the great pyramid. Each block weighs more than 2 tons.

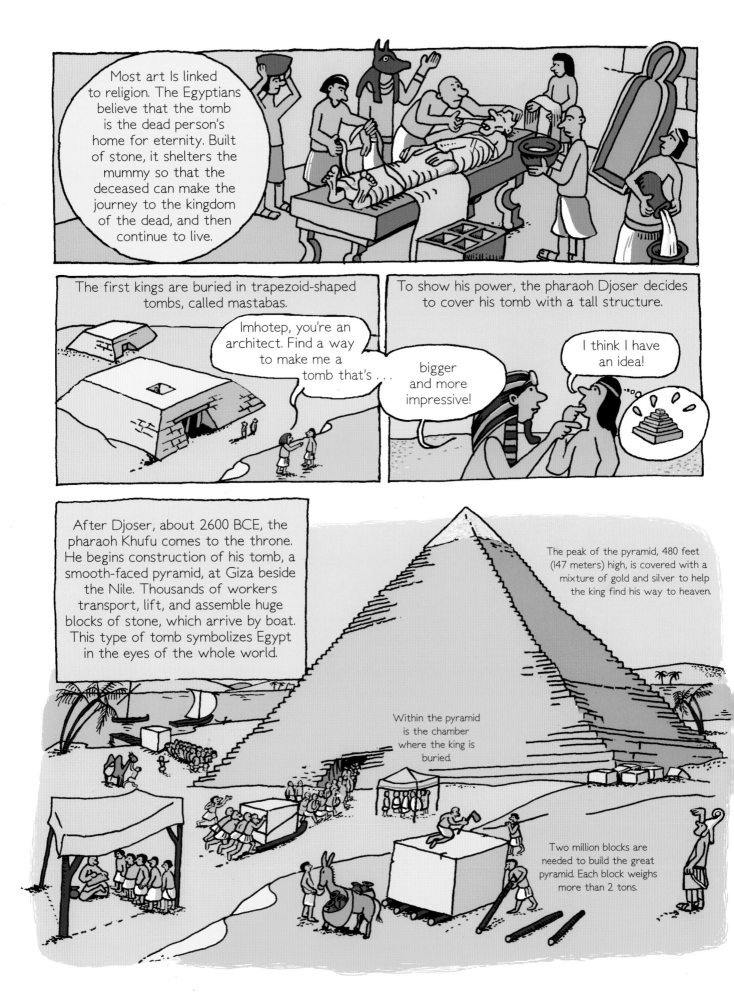

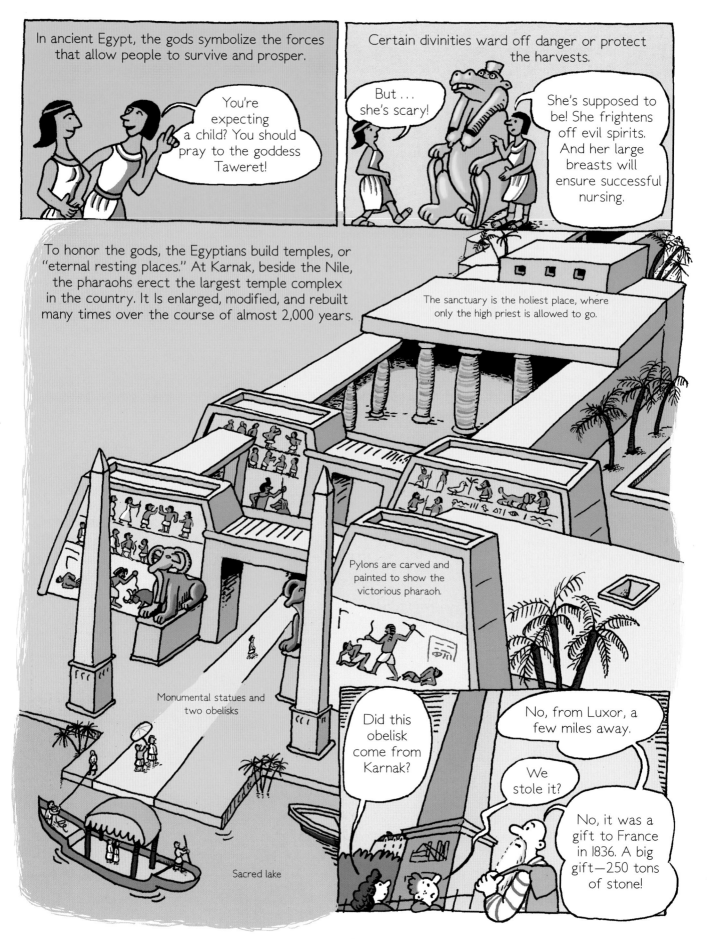

In ancient Egypt, the gods symbolize the forces that allow people to survive and prosper.

You're expecting a child? You should pray to the goddess Taweret!

Certain divinities ward off danger or protect the harvests.

But ... she's scary!

She's supposed to be! She frightens off evil spirits. And her large breasts will ensure successful nursing.

To honor the gods, the Egyptians build temples, or "eternal resting places." At Karnak, beside the Nile, the pharaohs erect the largest temple complex in the country. It Is enlarged, modified, and rebuilt many times over the course of almost 2,000 years.

The sanctuary is the holiest place, where only the high priest is allowed to go.

Pylons are carved and painted to show the victorious pharaoh.

Monumental statues and two obelisks

Did this obelisk come from Karnak?

No, from Luxor, a few miles away.

We stole it?

No, it was a gift to France in 1836. A big gift—250 tons of stone!

Sacred lake

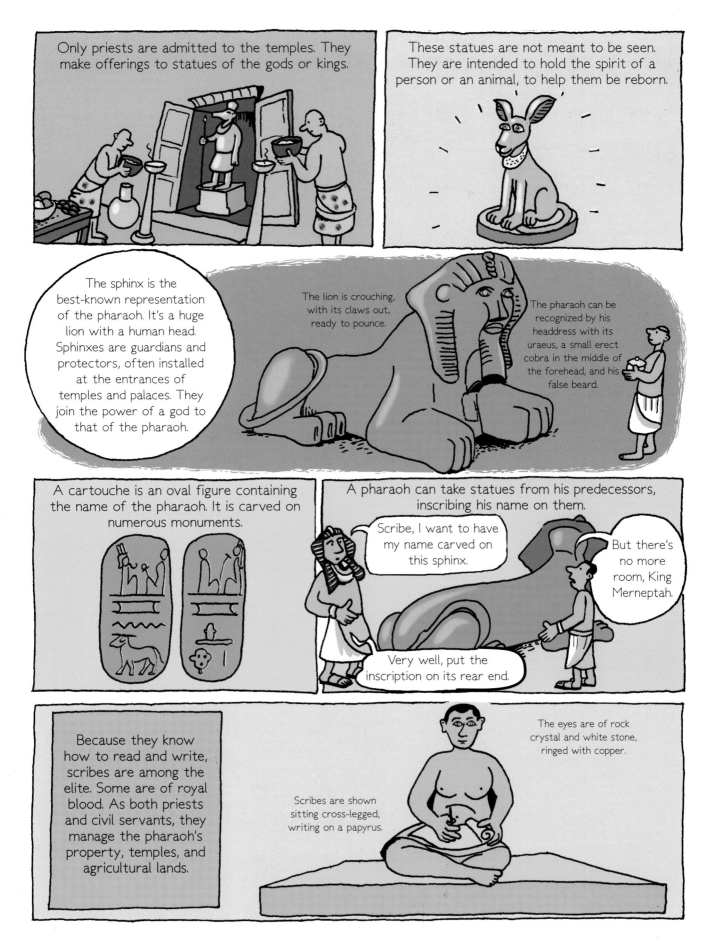

Only priests are admitted to the temples. They make offerings to statues of the gods or kings.

These statues are not meant to be seen. They are intended to hold the spirit of a person or an animal, to help them be reborn.

The sphinx is the best-known representation of the pharaoh. It's a huge lion with a human head. Sphinxes are guardians and protectors, often installed at the entrances of temples and palaces. They join the power of a god to that of the pharaoh.

The lion is crouching, with its claws out, ready to pounce.

The pharaoh can be recognized by his headdress with its uraeus, a small erect cobra in the middle of the forehead, and his false beard.

A cartouche is an oval figure containing the name of the pharaoh. It is carved on numerous monuments.

A pharaoh can take statues from his predecessors, inscribing his name on them.

Scribe, I want to have my name carved on this sphinx.

But there's no more room, King Merneptah.

Very well, put the inscription on its rear end.

Because they know how to read and write, scribes are among the elite. Some are of royal blood. As both priests and civil servants, they manage the pharaoh's property, temples, and agricultural lands.

The eyes are of rock crystal and white stone, ringed with copper.

Scribes are shown sitting cross-legged, writing on a papyrus.

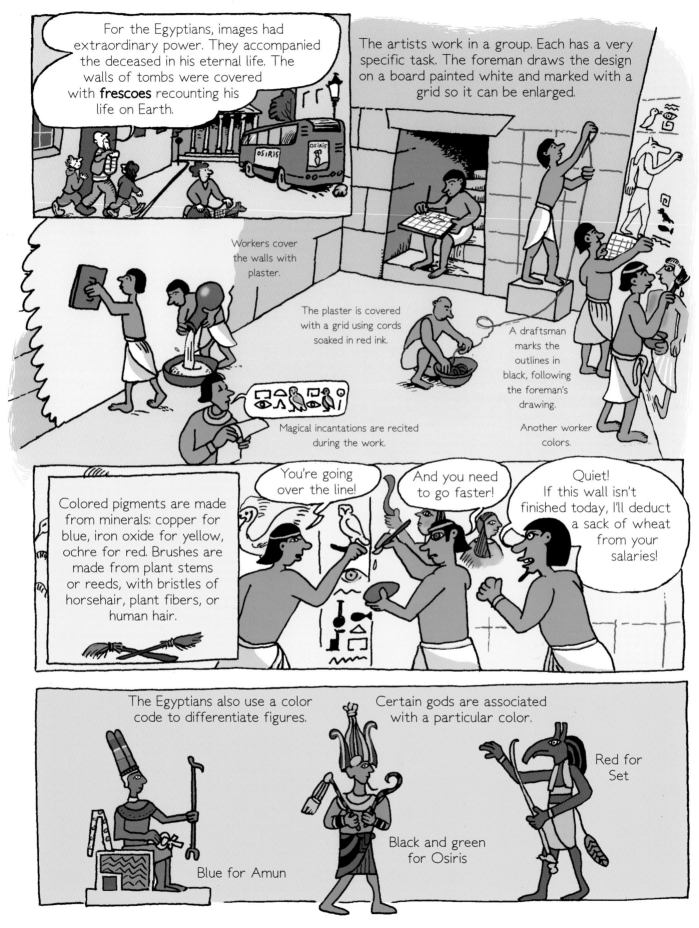

For the Egyptians, images had extraordinary power. They accompanied the deceased in his eternal life. The walls of tombs were covered with **frescoes** recounting his life on Earth.

The artists work in a group. Each has a very specific task. The foreman draws the design on a board painted white and marked with a grid so it can be enlarged.

Workers cover the walls with plaster.

The plaster is covered with a grid using cords soaked in red ink.

Magical incantations are recited during the work.

A draftsman marks the outlines in black, following the foreman's drawing.

Another worker colors.

Colored pigments are made from minerals: copper for blue, iron oxide for yellow, ochre for red. Brushes are made from plant stems or reeds, with bristles of horsehair, plant fibers, or human hair.

You're going over the line!

And you need to go faster!

Quiet! If this wall isn't finished today, I'll deduct a sack of wheat from your salaries!

The Egyptians also use a color code to differentiate figures.

Certain gods are associated with a particular color.

Red for Set

Blue for Amun

Black and green for Osiris

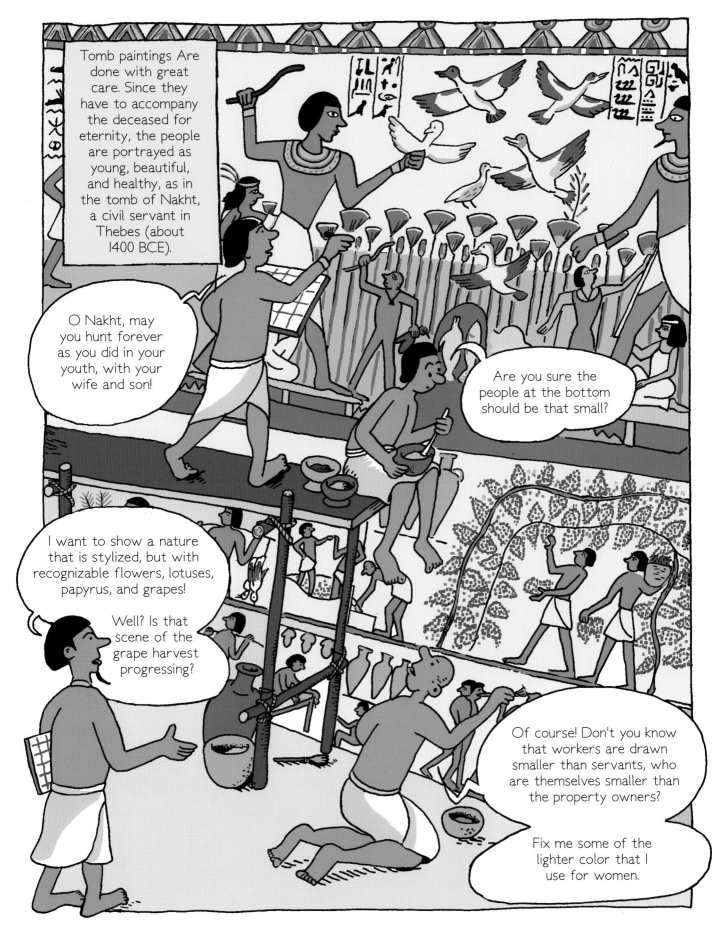

Tomb paintings Are done with great care. Since they have to accompany the deceased for eternity, the people are portrayed as young, beautiful, and healthy, as in the tomb of Nakht, a civil servant in Thebes (about 1400 BCE).

O Nakht, may you hunt forever as you did in your youth, with your wife and son!

Are you sure the people at the bottom should be that small?

I want to show a nature that is stylized, but with recognizable flowers, lotuses, papyrus, and grapes!

Well? Is that scene of the grape harvest progressing?

Of course! Don't you know that workers are drawn smaller than servants, who are themselves smaller than the property owners?

Fix me some of the lighter color that I use for women.

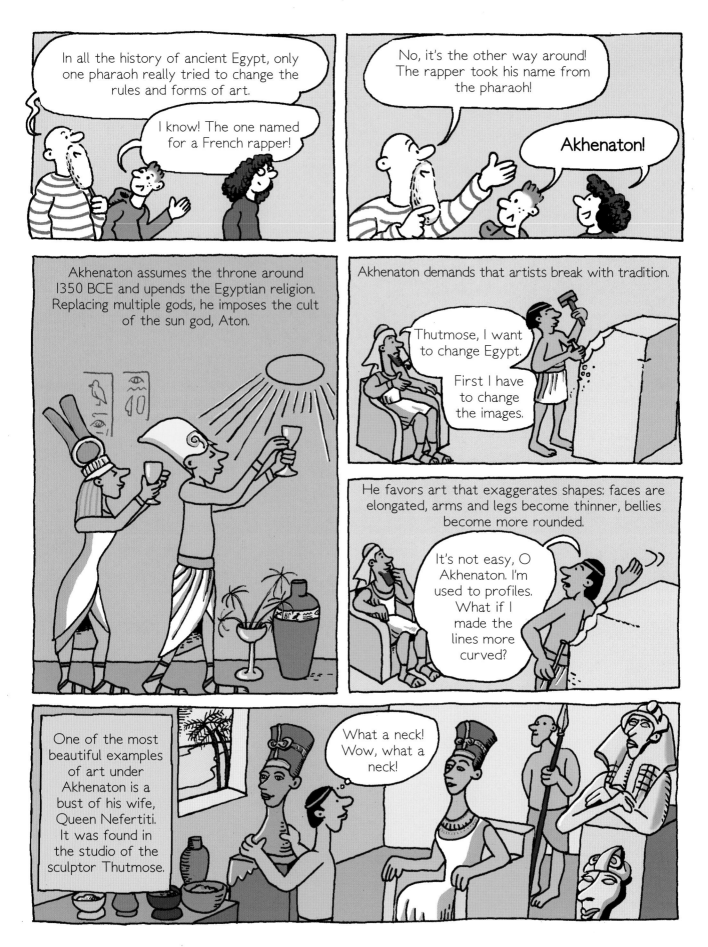

But the revolution that Akhenaton hoped for lasts only as long as his reign. His son Tutankhamen succeeds him. Thanks to the discovery of his tomb in 1922, intact and filled with treasures, today he is the best-known pharaoh.

Among the marvels in the tomb of Tutankhamen is his funeral mask, which covered the mummy's face. It shows the Egyptians' extraordinary talent for goldsmithing. Finely tooled yellow and rose gold are inlaid with colored glass and precious stones.

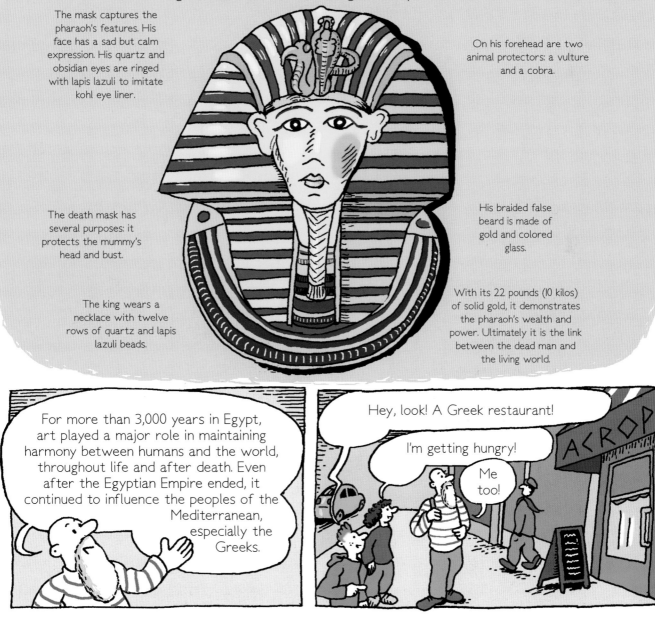

The mask captures the pharaoh's features. His face has a sad but calm expression. His quartz and obsidian eyes are ringed with lapis lazuli to imitate kohl eye liner.

On his forehead are two animal protectors: a vulture and a cobra.

The death mask has several purposes: it protects the mummy's head and bust.

His braided false beard is made of gold and colored glass.

The king wears a necklace with twelve rows of quartz and lapis lazuli beads.

With its 22 pounds (10 kilos) of solid gold, it demonstrates the pharaoh's wealth and power. Ultimately it is the link between the dead man and the living world.

For more than 3,000 years in Egypt, art played a major role in maintaining harmony between humans and the world, throughout life and after death. Even after the Egyptian Empire ended, it continued to influence the peoples of the Mediterranean, especially the Greeks.

Hey, look! A Greek restaurant!

I'm getting hungry!

Me too!

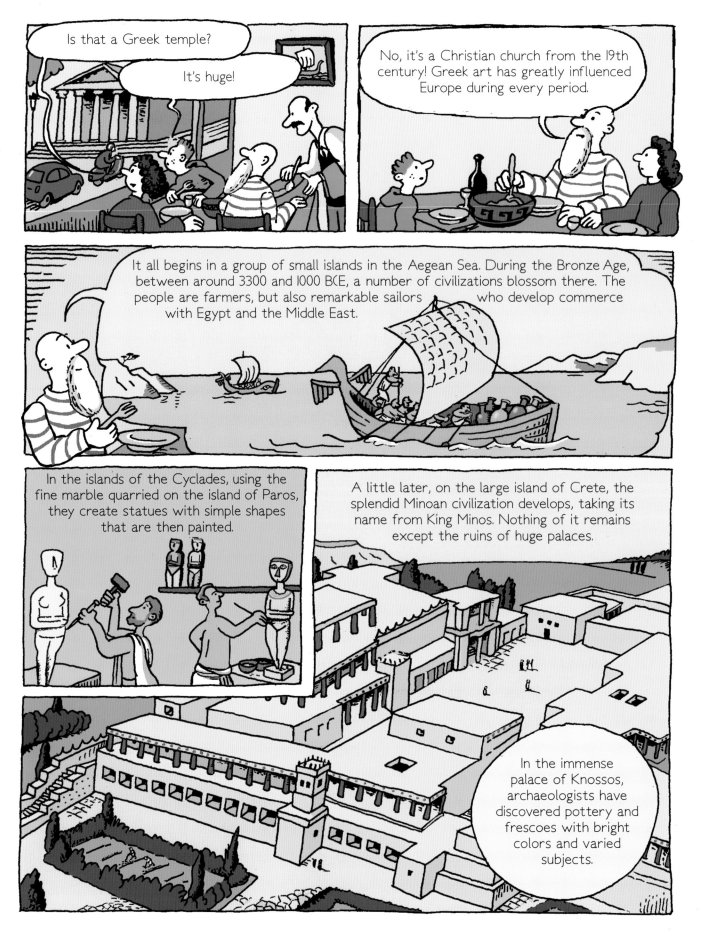

Is that a Greek temple?

It's huge!

No, it's a Christian church from the 19th century! Greek art has greatly influenced Europe during every period.

It all begins in a group of small islands in the Aegean Sea. During the Bronze Age, between around 3300 and 1000 BCE, a number of civilizations blossom there. The people are farmers, but also remarkable sailors who develop commerce with Egypt and the Middle East.

In the islands of the Cyclades, using the fine marble quarried on the island of Paros, they create statues with simple shapes that are then painted.

A little later, on the large island of Crete, the splendid Minoan civilization develops, taking its name from King Minos. Nothing of it remains except the ruins of huge palaces.

In the immense palace of Knossos, archaeologists have discovered pottery and frescoes with bright colors and varied subjects.

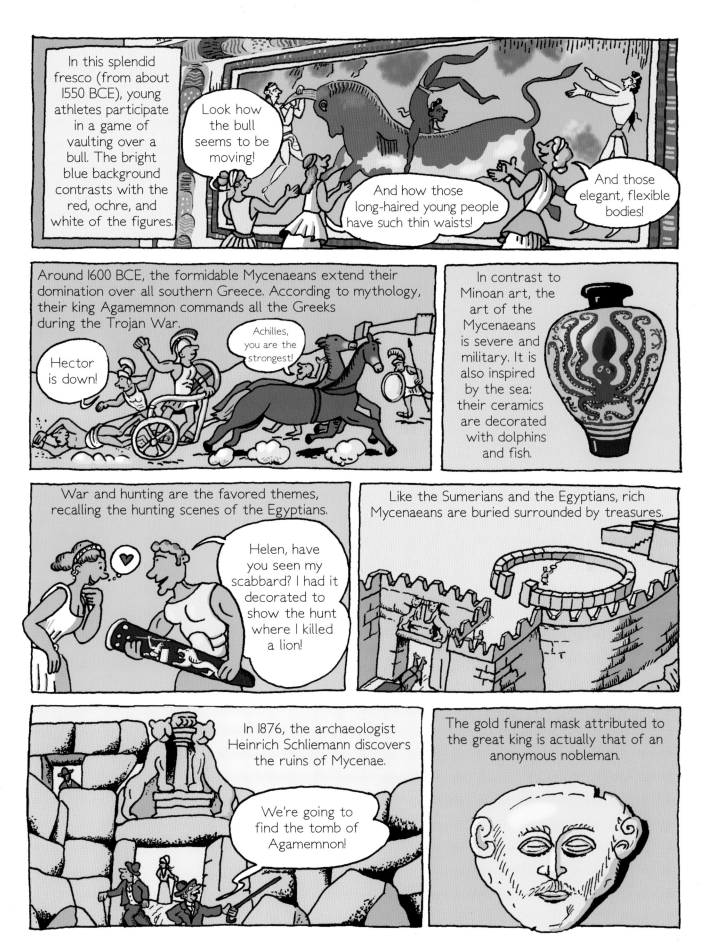

In this splendid fresco (from about 1550 BCE), young athletes participate in a game of vaulting over a bull. The bright blue background contrasts with the red, ochre, and white of the figures.

Look how the bull seems to be moving!

And how those long-haired young people have such thin waists!

And those elegant, flexible bodies!

Around 1600 BCE, the formidable Mycenaeans extend their domination over all southern Greece. According to mythology, their king Agamemnon commands all the Greeks during the Trojan War.

Achilles, you are the strongest!

Hector is down!

In contrast to Minoan art, the art of the Mycenaeans is severe and military. It is also inspired by the sea: their ceramics are decorated with dolphins and fish.

War and hunting are the favored themes, recalling the hunting scenes of the Egyptians.

Helen, have you seen my scabbard? I had it decorated to show the hunt where I killed a lion!

Like the Sumerians and the Egyptians, rich Mycenaeans are buried surrounded by treasures.

In 1876, the archaeologist Heinrich Schliemann discovers the ruins of Mycenae.

We're going to find the tomb of Agamemnon!

The gold funeral mask attributed to the great king is actually that of an anonymous nobleman.

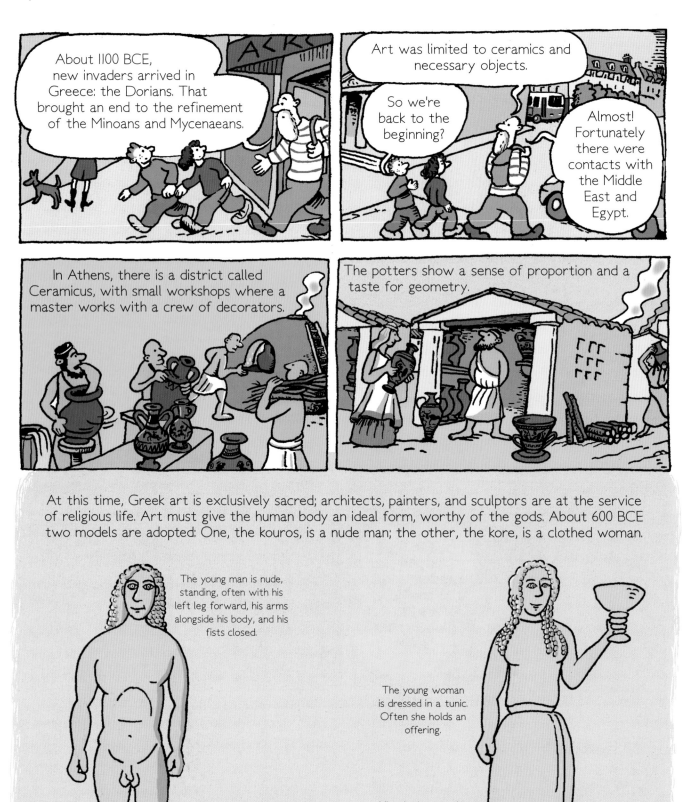

About 1100 BCE, new invaders arrived in Greece: the Dorians. That brought an end to the refinement of the Minoans and Mycenaeans.

Art was limited to ceramics and necessary objects.

So we're back to the beginning?

Almost! Fortunately there were contacts with the Middle East and Egypt.

In Athens, there is a district called Ceramicus, with small workshops where a master works with a crew of decorators.

The potters show a sense of proportion and a taste for geometry.

At this time, Greek art is exclusively sacred; architects, painters, and sculptors are at the service of religious life. Art must give the human body an ideal form, worthy of the gods. About 600 BCE two models are adopted: One, the kouros, is a nude man; the other, the kore, is a clothed woman.

The young man is nude, standing, often with his left leg forward, his arms alongside his body, and his fists closed.

Inspired by Egyptian art, the kouros represents the hero.

The young woman is dressed in a tunic. Often she holds an offering.

Like the kouros, she wears a forced smile: the "archaic smile."

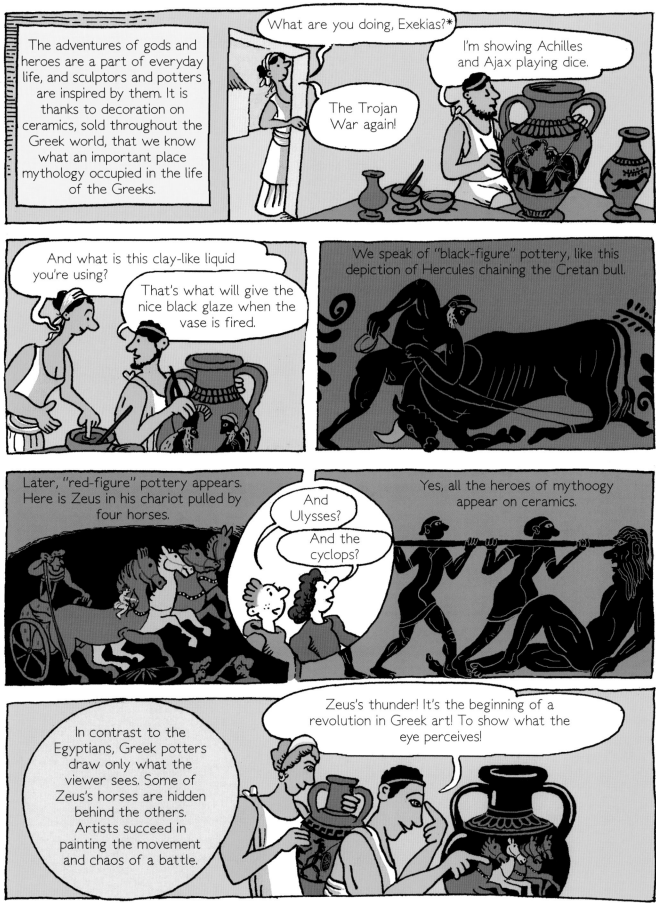

The adventures of gods and heroes are a part of everyday life, and sculptors and potters are inspired by them. It is thanks to decoration on ceramics, sold throughout the Greek world, that we know what an important place mythology occupied in the life of the Greeks.

What are you doing, Exekias?*

The Trojan War again!

I'm showing Achilles and Ajax playing dice.

And what is this clay-like liquid you're using?

That's what will give the nice black glaze when the vase is fired.

We speak of "black-figure" pottery, like this depiction of Hercules chaining the Cretan bull.

Later, "red-figure" pottery appears. Here is Zeus in his chariot pulled by four horses.

And Ulysses?

And the cyclops?

Yes, all the heroes of mythoogy appear on ceramics.

In contrast to the Egyptians, Greek potters draw only what the viewer sees. Some of Zeus's horses are hidden behind the others. Artists succeed in painting the movement and chaos of a battle.

Zeus's thunder! It's the beginning of a revolution in Greek art! To show what the eye perceives!

*Exekias was a Greek potter active between 550 and 525 BCE.

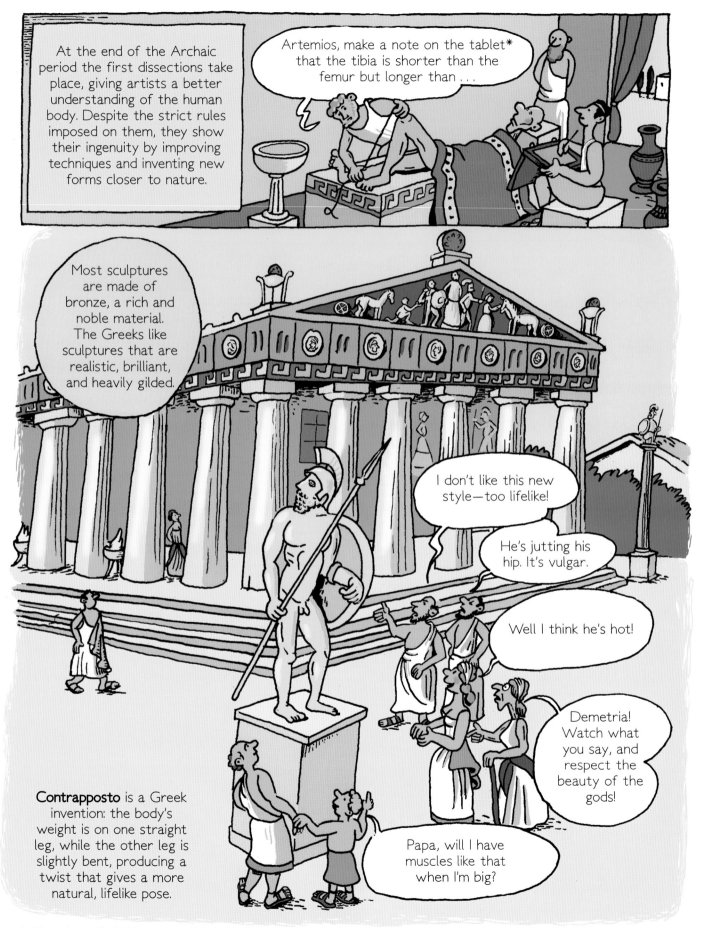

At the end of the Archaic period the first dissections take place, giving artists a better understanding of the human body. Despite the strict rules imposed on them, they show their ingenuity by improving techniques and inventing new forms closer to nature.

Artemios, make a note on the tablet* that the tibia is shorter than the femur but longer than . . .

Most sculptures are made of bronze, a rich and noble material. The Greeks like sculptures that are realistic, brilliant, and heavily gilded.

I don't like this new style—too lifelike!

He's jutting his hip. It's vulgar.

Well I think he's hot!

Demetria! Watch what you say, and respect the beauty of the gods!

Contrapposto is a Greek invention: the body's weight is on one straight leg, while the other leg is slightly bent, producing a twist that gives a more natural, lifelike pose.

Papa, will I have muscles like that when I'm big?

*tablet: a frame filled with wax, on which the Greeks wrote with a stylus.

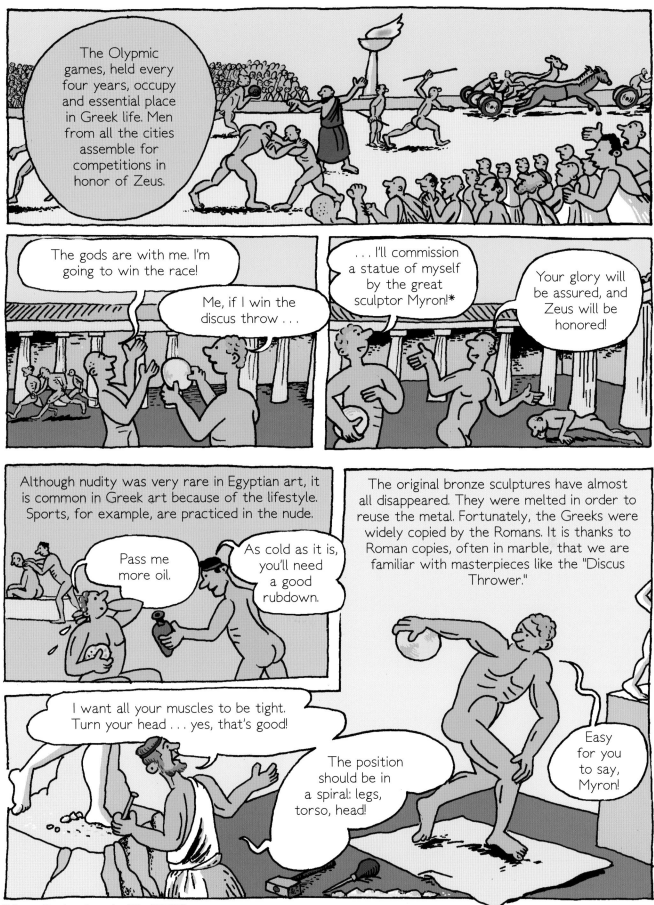

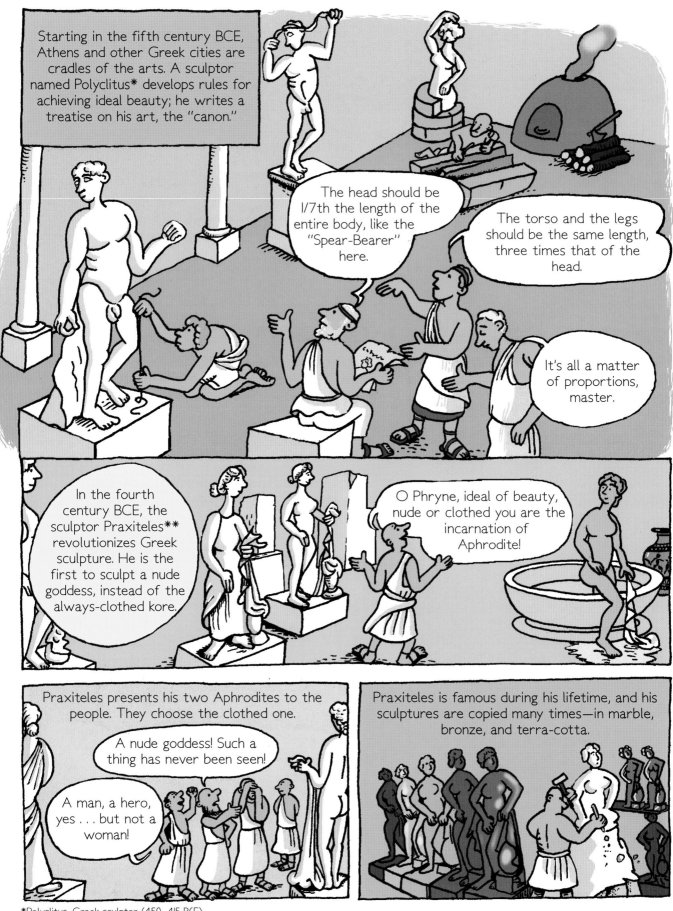

*Polyclitus, Greek sculptor (450–415 BCE)
**Praxiteles, Greek sculptor (370–330 BCE)

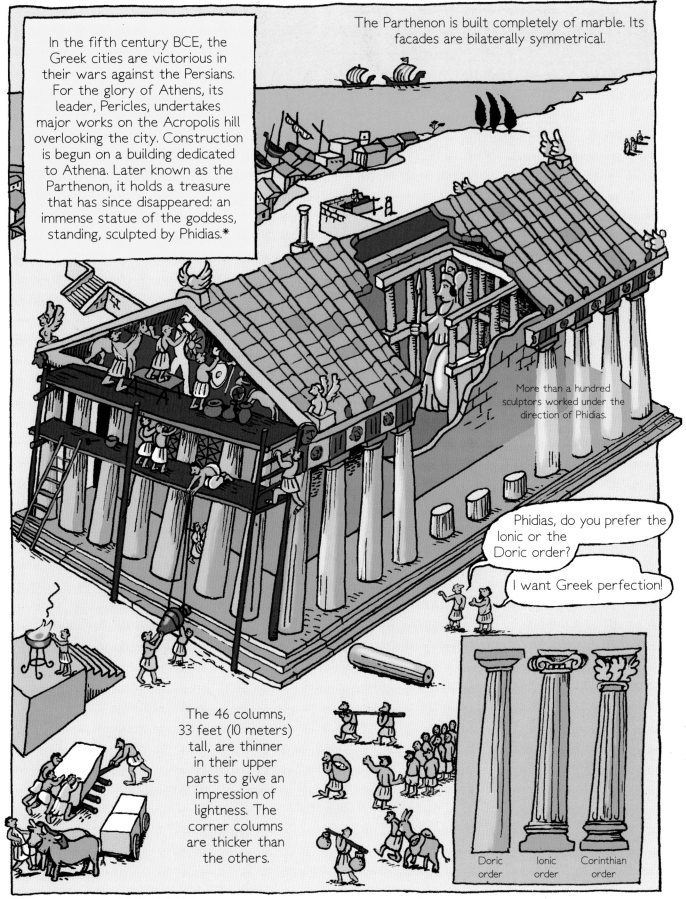

In the fifth century BCE, the Greek cities are victorious in their wars against the Persians. For the glory of Athens, its leader, Pericles, undertakes major works on the Acropolis hill overlooking the city. Construction is begun on a building dedicated to Athena. Later known as the Parthenon, it holds a treasure that has since disappeared: an immense statue of the goddess, standing, sculpted by Phidias.*

The Parthenon is built completely of marble. Its facades are bilaterally symmetrical.

More than a hundred sculptors worked under the direction of Phidias.

Phidias, do you prefer the Ionic or the Doric order?

I want Greek perfection!

The 46 columns, 33 feet (10 meters) tall, are thinner in their upper parts to give an impression of lightness. The corner columns are thicker than the others.

Doric order

Ionic order

Corinthian order

*Phidias, Greek sculptor (c. 490–430 BCE)

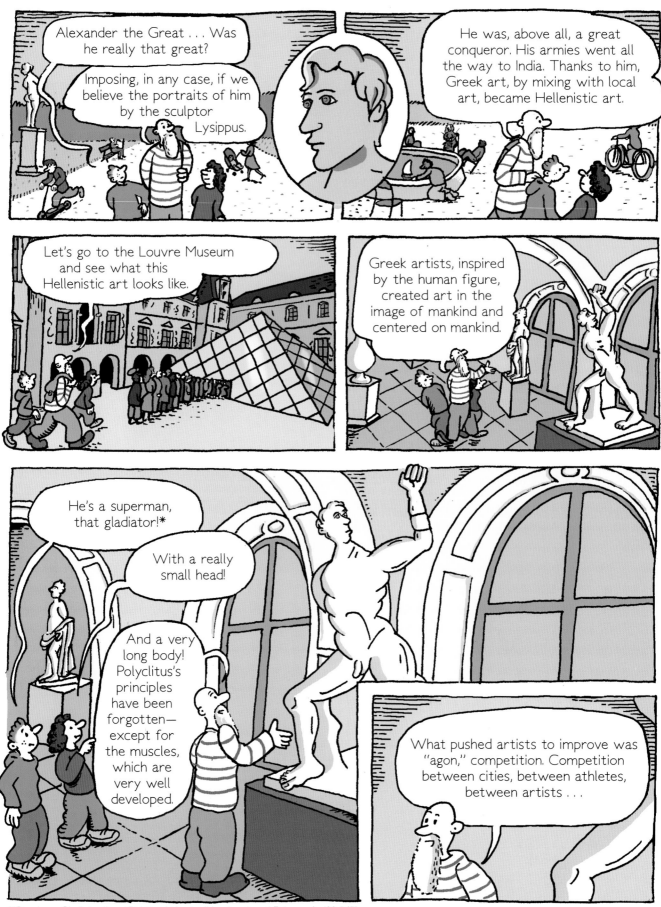

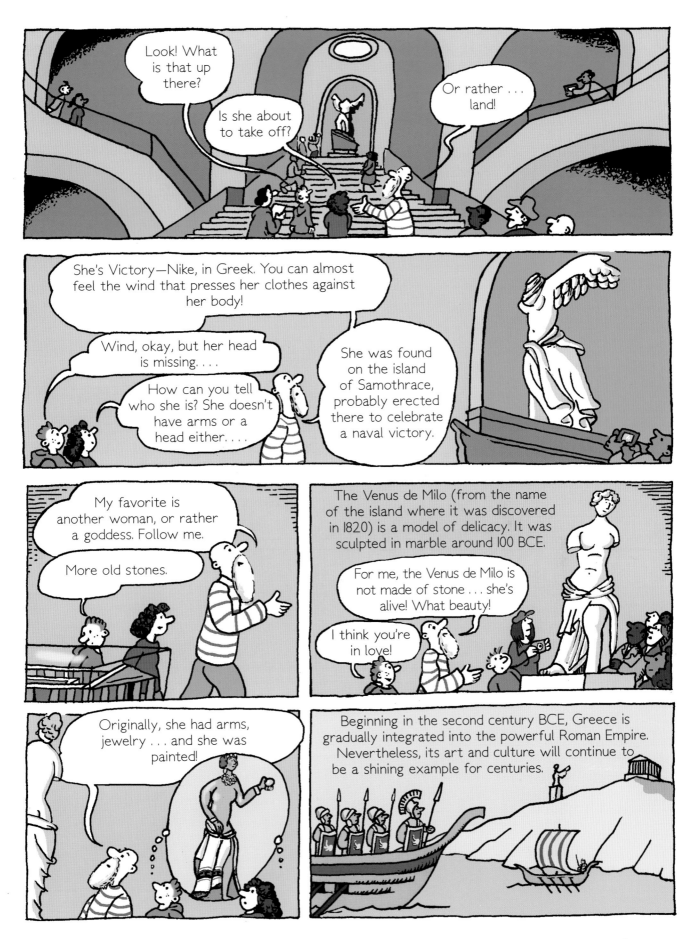

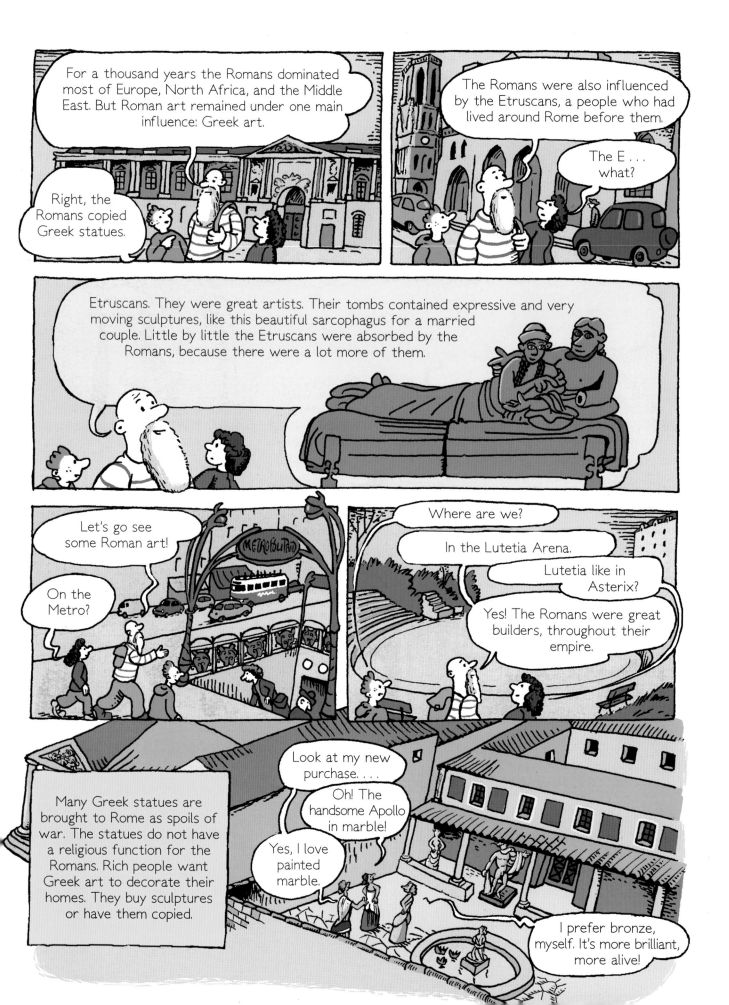

The statue of the man wearing a breastplate is a Roman creation. Augustus, with his right arm raised, addresses his soldiers as emperor and conquering general.

He is not a god, but a man. His lined face is recognizable.

With his weight on his right leg, his posture recalls that of Greek statues.

Around his hips he wears the Roman military cloak.

On the breastplate, the artist depicts Augustus's victory at Actium.

Apollo is there to protect Augustus.

The Romans are great builders. Inspired at first by Greek temples, they innovate and invent new forms.

I love these round temples, like the one at the Forum Boarium.

By Jupiter, not me!

I much prefer the new Pantheon. Did the Greeks ever make a dome like that?

Roman concrete is composed of small pieces of rock and a sticky material, mortar. Poured between planks, the mixture becomes very strong.

In a crowded city, this invention permits the use of unskilled workers to construct large buildings quickly and cheaply. Roman concrete may be covered with bricks, stones, marble . . .

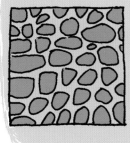
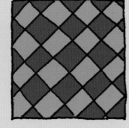
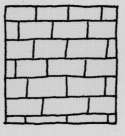

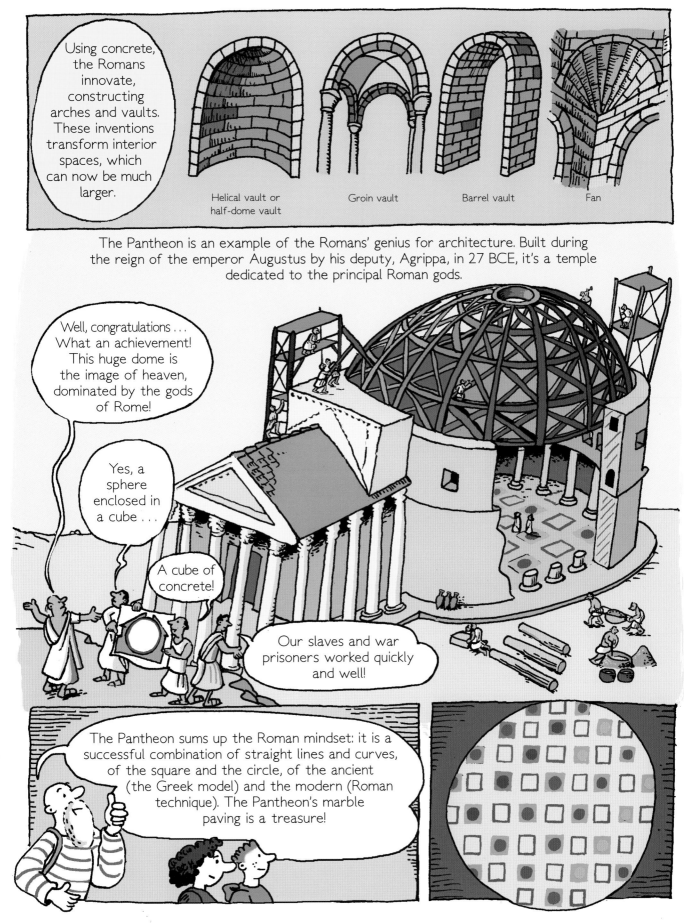

Using concrete, the Romans innovate, constructing arches and vaults. These inventions transform interior spaces, which can now be much larger.

Helical vault or half-dome vault

Groin vault

Barrel vault

Fan

The Pantheon is an example of the Romans' genius for architecture. Built during the reign of the emperor Augustus by his deputy, Agrippa, in 27 BCE, it's a temple dedicated to the principal Roman gods.

Well, congratulations... What an achievement! This huge dome is the image of heaven, dominated by the gods of Rome!

Yes, a sphere enclosed in a cube...

A cube of concrete!

Our slaves and war prisoners worked quickly and well!

The Pantheon sums up the Roman mindset: it is a successful combination of straight lines and curves, of the square and the circle, of the ancient (the Greek model) and the modern (Roman technique). The Pantheon's marble paving is a treasure!

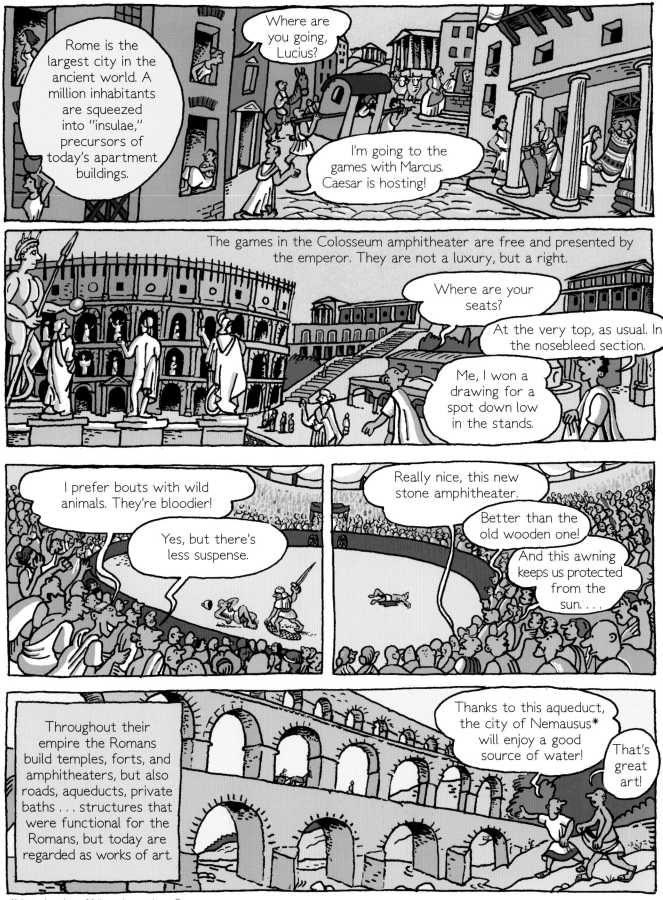

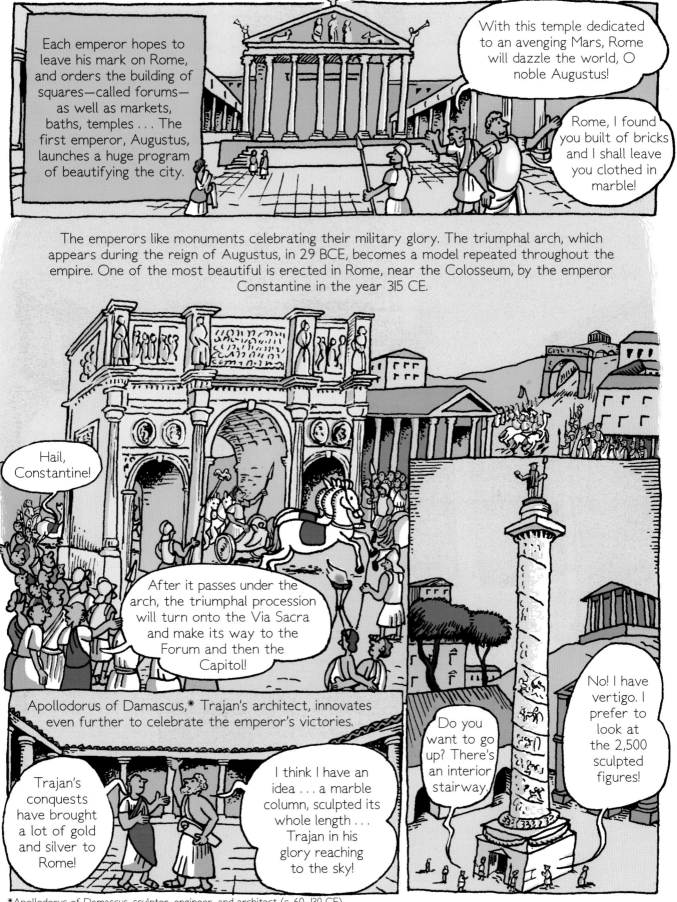

Each emperor hopes to leave his mark on Rome, and orders the building of squares—called forums—as well as markets, baths, temples . . . The first emperor, Augustus, launches a huge program of beautifying the city.

With this temple dedicated to an avenging Mars, Rome will dazzle the world, O noble Augustus!

Rome, I found you built of bricks and I shall leave you clothed in marble!

The emperors like monuments celebrating their military glory. The triumphal arch, which appears during the reign of Augustus, in 29 BCE, becomes a model repeated throughout the empire. One of the most beautiful is erected in Rome, near the Colosseum, by the emperor Constantine in the year 315 CE.

Hail, Constantine!

After it passes under the arch, the triumphal procession will turn onto the Via Sacra and make its way to the Forum and then the Capitol!

Apollodorus of Damascus,* Trajan's architect, innovates even further to celebrate the emperor's victories.

Trajan's conquests have brought a lot of gold and silver to Rome!

I think I have an idea . . . a marble column, sculpted its whole length . . . Trajan in his glory reaching to the sky!

Do you want to go up? There's an interior stairway.

No! I have vertigo. I prefer to look at the 2,500 sculpted figures!

*Apollodorus of Damascus, sculptor, engineer, and architect (c. 60–130 CE)

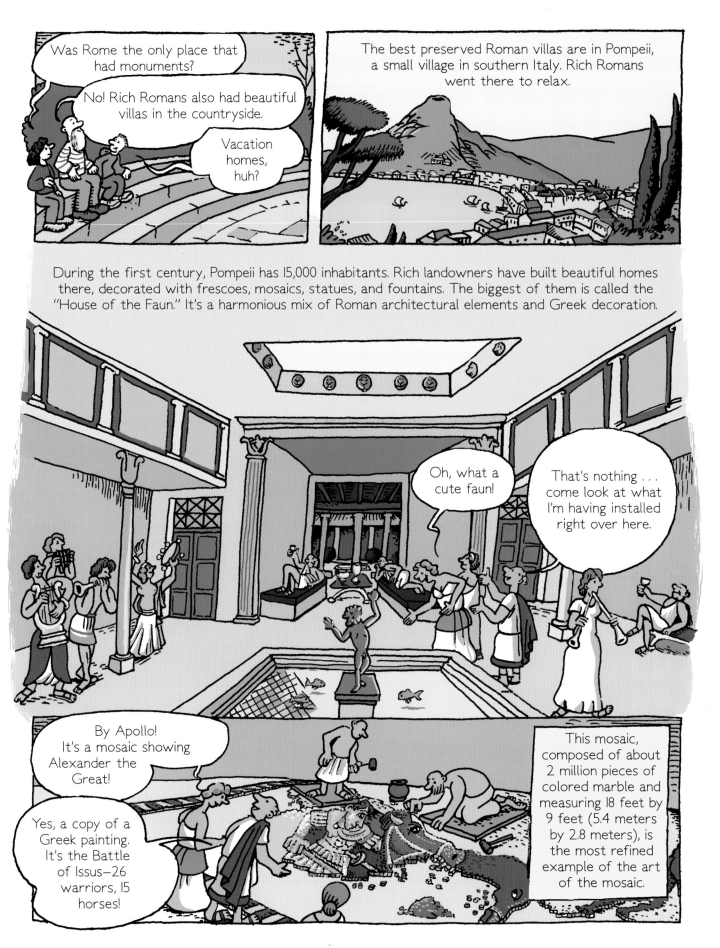

Was Rome the only place that had monuments?

No! Rich Romans also had beautiful villas in the countryside.

Vacation homes, huh?

The best preserved Roman villas are in Pompeii, a small village in southern Italy. Rich Romans went there to relax.

During the first century, Pompeii has 15,000 inhabitants. Rich landowners have built beautiful homes there, decorated with frescoes, mosaics, statues, and fountains. The biggest of them is called the "House of the Faun." It's a harmonious mix of Roman architectural elements and Greek decoration.

Oh, what a cute faun!

That's nothing . . . come look at what I'm having installed right over here.

By Apollo! It's a mosaic showing Alexander the Great!

Yes, a copy of a Greek painting. It's the Battle of Issus—26 warriors, 15 horses!

This mosaic, composed of about 2 million pieces of colored marble and measuring 18 feet by 9 feet (5.4 meters by 2.8 meters), is the most refined example of the art of the mosaic.

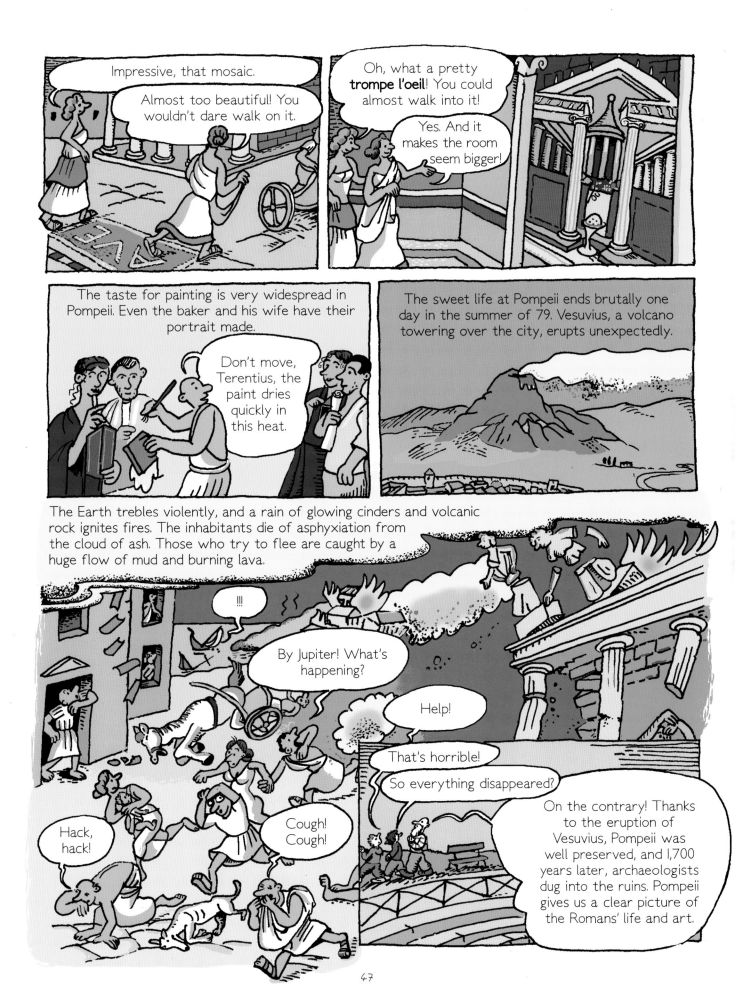

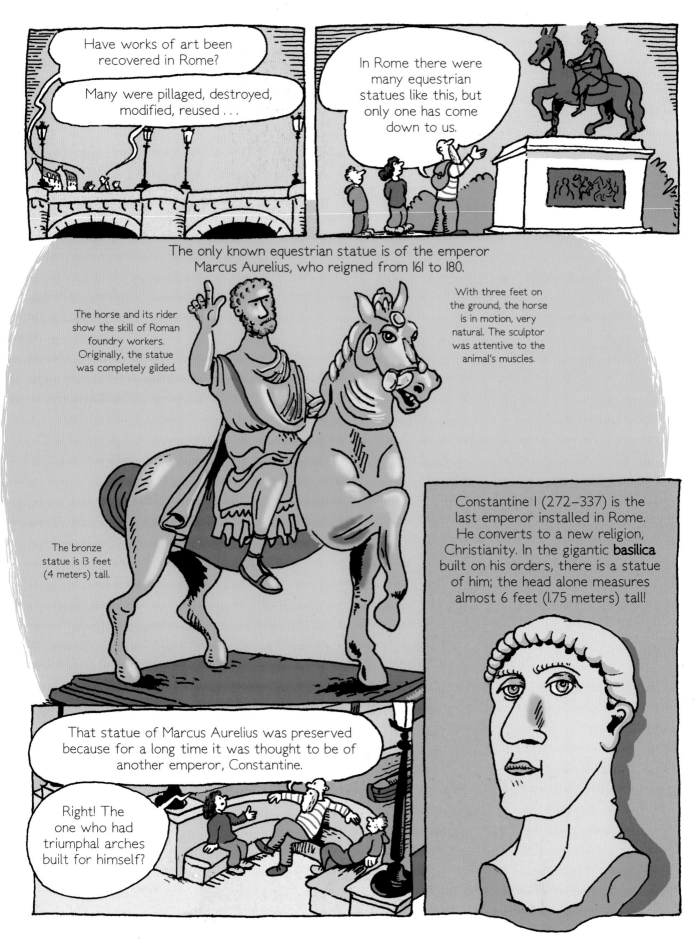

Have works of art been recovered in Rome?

Many were pillaged, destroyed, modified, reused . . .

In Rome there were many equestrian statues like this, but only one has come down to us.

The only known equestrian statue is of the emperor Marcus Aurelius, who reigned from 161 to 180.

The horse and its rider show the skill of Roman foundry workers. Originally, the statue was completely gilded.

With three feet on the ground, the horse is in motion, very natural. The sculptor was attentive to the animal's muscles.

The bronze statue is 13 feet (4 meters) tall.

Constantine I (272–337) is the last emperor installed in Rome. He converts to a new religion, Christianity. In the gigantic **basilica** built on his orders, there is a statue of him; the head alone measures almost 6 feet (1.75 meters) tall!

That statue of Marcus Aurelius was preserved because for a long time it was thought to be of another emperor, Constantine.

Right! The one who had triumphal arches built for himself?

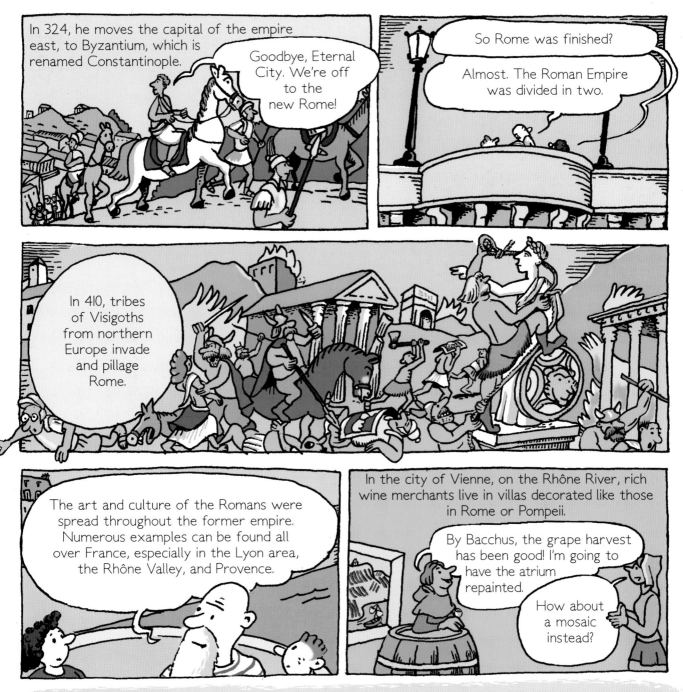

In 324, he moves the capital of the empire east, to Byzantium, which is renamed Constantinople.

Goodbye, Eternal City. We're off to the new Rome!

So Rome was finished?

Almost. The Roman Empire was divided in two.

In 410, tribes of Visigoths from northern Europe invade and pillage Rome.

The art and culture of the Romans were spread throughout the former empire. Numerous examples can be found all over France, especially in the Lyon area, the Rhône Valley, and Provence.

In the city of Vienne, on the Rhône River, rich wine merchants live in villas decorated like those in Rome or Pompeii.

By Bacchus, the grape harvest has been good! I'm going to have the atrium repainted.

How about a mosaic instead?

Splendid mosaics have been found at Saint-Romain-en-Gal, across the river from Vienne. They feature original themes such as agricultural activies: sowing, pruning trees, plowing, harvesting grapes, picking apples. This new art, along with the coming of Christianity, signals the beginning of the Middle Ages.

Time Line of the Middle Ages and the Renaissance

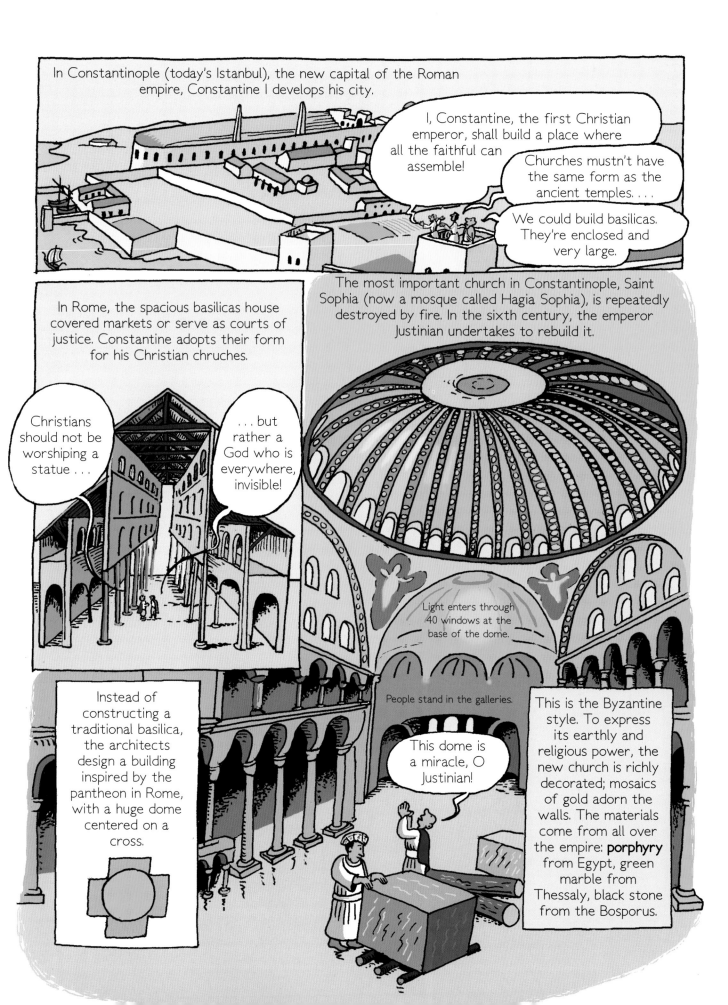

In Constantinople (today's Istanbul), the new capital of the Roman empire, Constantine I develops his city.

I, Constantine, the first Christian emperor, shall build a place where all the faithful can assemble!

Churches mustn't have the same form as the ancient temples. . . .

We could build basilicas. They're enclosed and very large.

In Rome, the spacious basilicas house covered markets or serve as courts of justice. Constantine adopts their form for his Christian chruches.

Christians should not be worshiping a statue . . .

. . . but rather a God who is everywhere, invisible!

The most important church in Constantinople, Saint Sophia (now a mosque called Hagia Sophia), is repeatedly destroyed by fire. In the sixth century, the emperor Justinian undertakes to rebuild it.

Light enters through 40 windows at the base of the dome.

People stand in the galleries.

Instead of constructing a traditional basilica, the architects design a building inspired by the pantheon in Rome, with a huge dome centered on a cross.

This dome is a miracle, O Justinian!

This is the Byzantine style. To express its earthly and religious power, the new church is richly decorated; mosaics of gold adorn the walls. The materials come from all over the empire: **porphyry** from Egypt, green marble from Thessaly, black stone from the Bosporus.

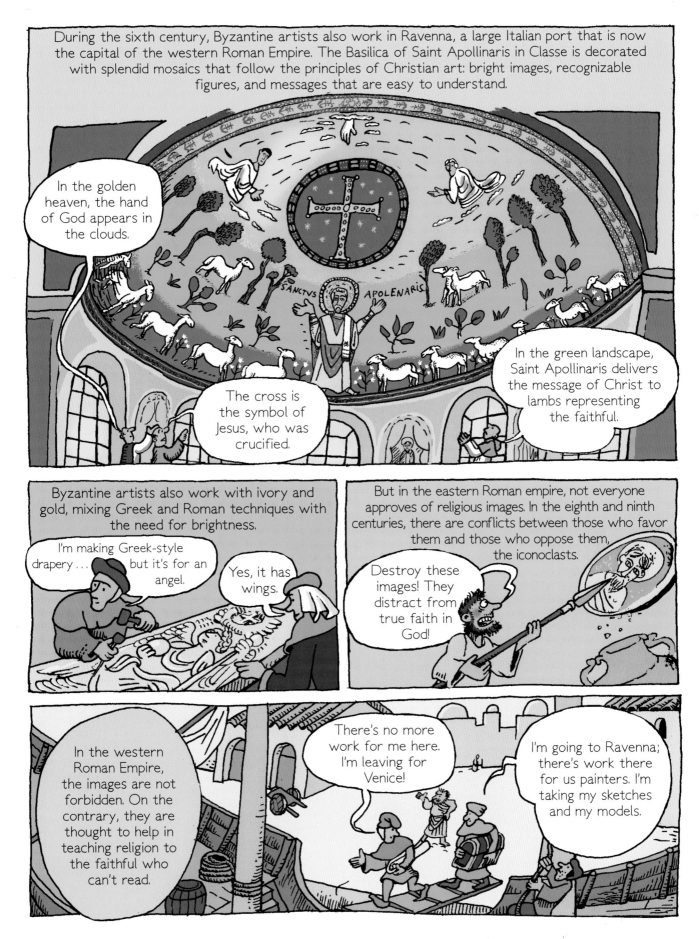

During the sixth century, Byzantine artists also work in Ravenna, a large Italian port that is now the capital of the western Roman Empire. The Basilica of Saint Apollinaris in Classe is decorated with splendid mosaics that follow the principles of Christian art: bright images, recognizable figures, and messages that are easy to understand.

In the golden heaven, the hand of God appears in the clouds.

The cross is the symbol of Jesus, who was crucified.

In the green landscape, Saint Apollinaris delivers the message of Christ to lambs representing the faithful.

Byzantine artists also work with ivory and gold, mixing Greek and Roman techniques with the need for brightness.

I'm making Greek-style drapery . . . but it's for an angel.

Yes, it has wings.

But in the eastern Roman empire, not everyone approves of religious images. In the eighth and ninth centuries, there are conflicts between those who favor them and those who oppose them, the iconoclasts.

Destroy these images! They distract from true faith in God!

In the western Roman Empire, the images are not forbidden. On the contrary, they are thought to help in teaching religion to the faithful who can't read.

There's no more work for me here. I'm leaving for Venice!

I'm going to Ravenna; there's work there for us painters. I'm taking my sketches and my models.

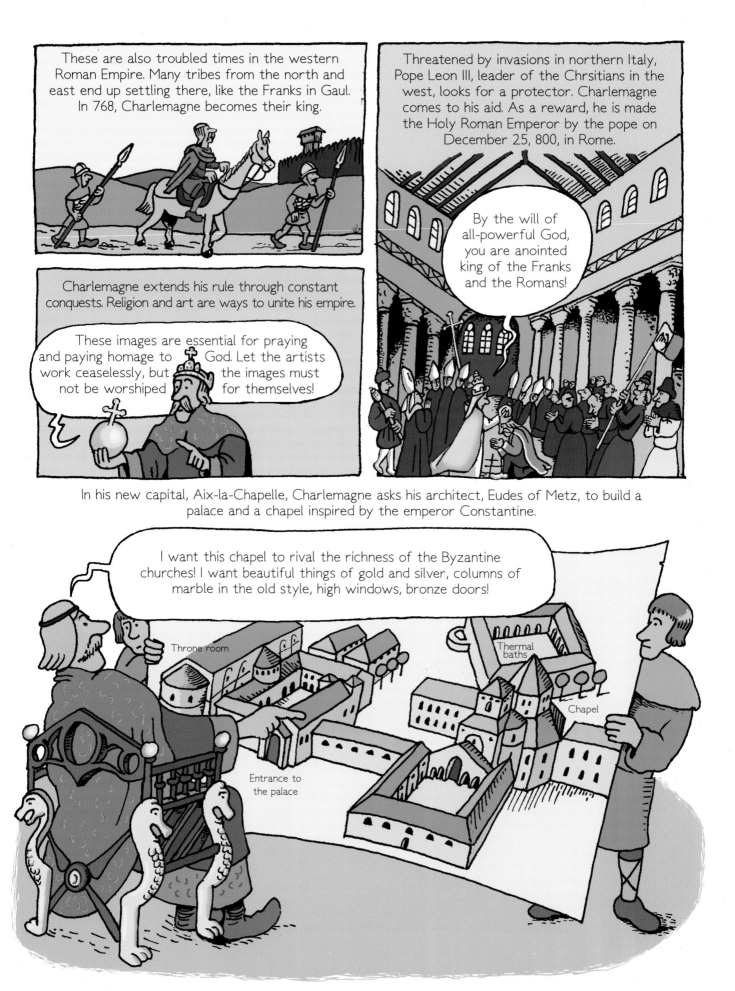

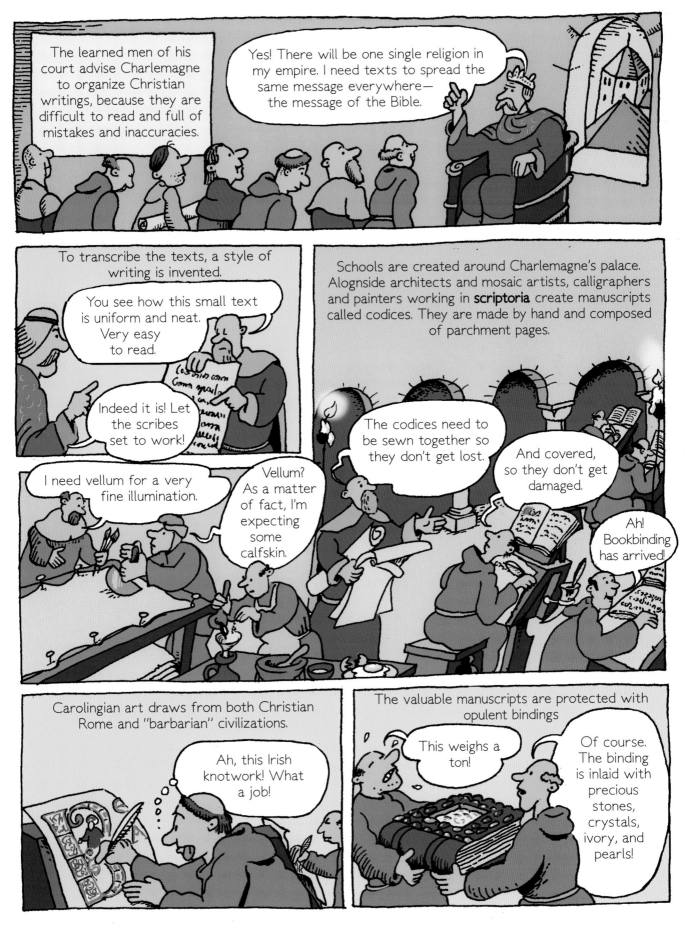

The Carolingian sovereigns are also inspired by statues of Roman emperors as a way of affirming their power. This small statue (1 inch / 2.5 centimeters tall) representing Charlemagne has survived. Its value was originally enhanced by the fact that it was gilded.

Palaces are decorated with furnishings, wall hangings, and curtains, very few of which remain today.

The famous Bayeux Tapestry, which dates from the eleventh century, is one of the few artistic textiles that we have. This large embroidered wall hanging recounts the conquest of England by the Duke of Normandy, William the Conqueror, in 1066. The tapestry is 224 feet (68 meters) long and 20 inches (50 centimeters) wide.

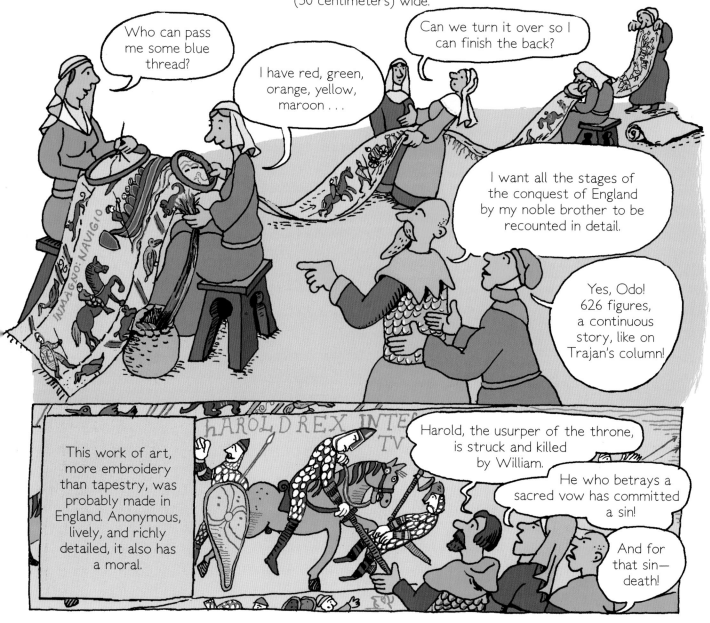

Who can pass me some blue thread?

I have red, green, orange, yellow, maroon . . .

Can we turn it over so I can finish the back?

I want all the stages of the conquest of England by my noble brother to be recounted in detail.

Yes, Odo! 626 figures, a continuous story, like on Trajan's column!

This work of art, more embroidery than tapestry, was probably made in England. Anonymous, lively, and richly detailed, it also has a moral.

Harold, the usurper of the throne, is struck and killed by William.

He who betrays a sacred vow has committed a sin!

And for that sin— death!

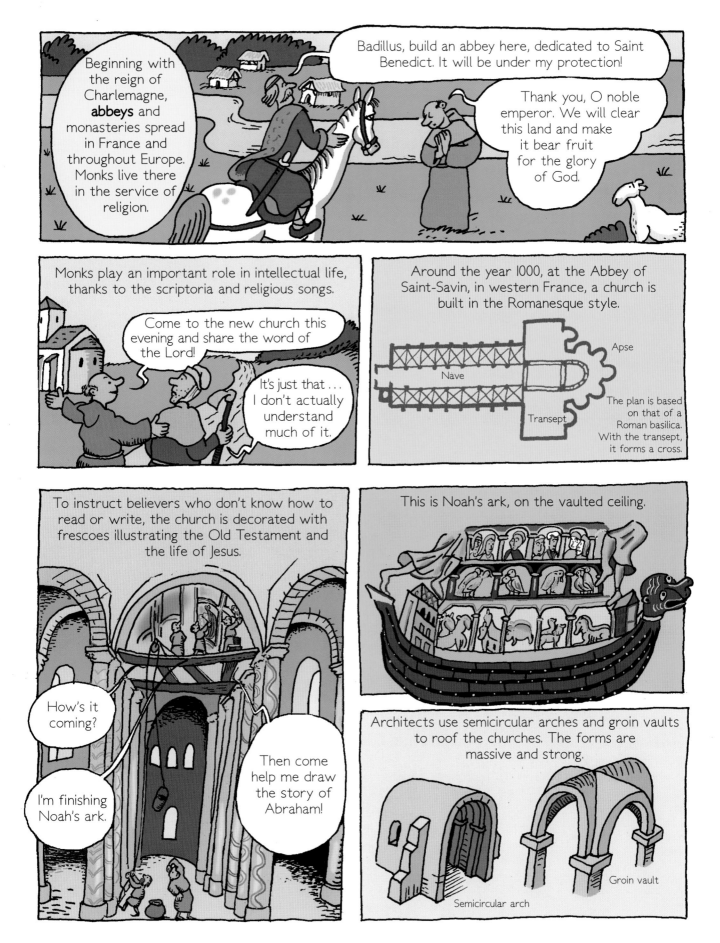

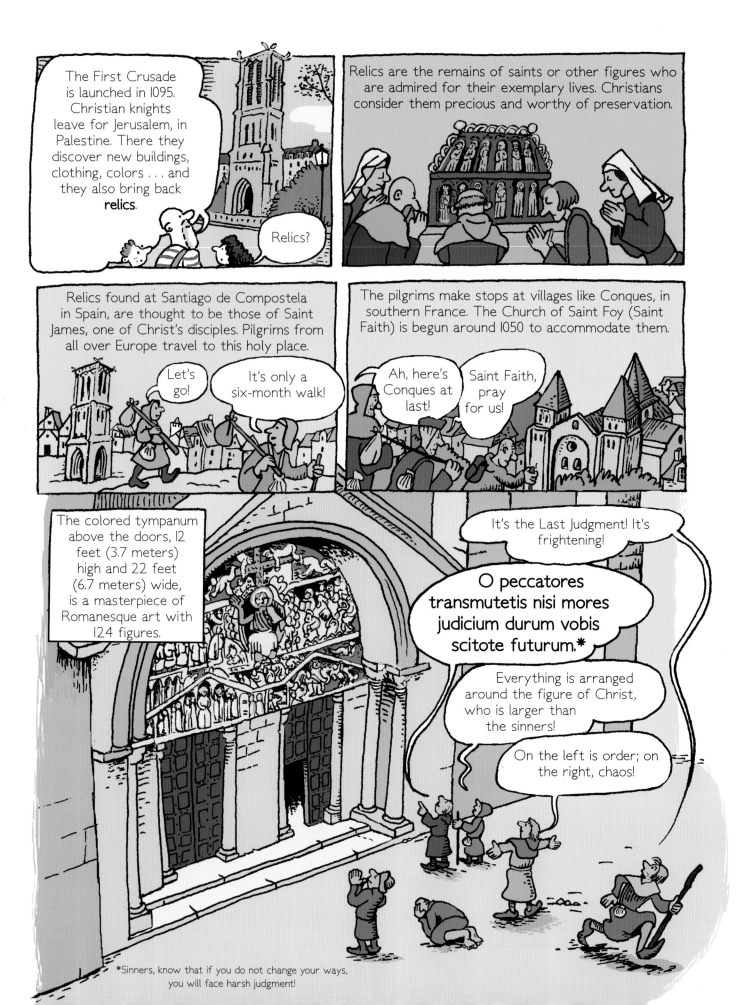

The First Crusade is launched in 1095. Christian knights leave for Jerusalem, in Palestine. There they discover new buildings, clothing, colors . . . and they also bring back **relics**.

Relics?

Relics are the remains of saints or other figures who are admired for their exemplary lives. Christians consider them precious and worthy of preservation.

Relics found at Santiago de Compostela in Spain, are thought to be those of Saint James, one of Christ's disciples. Pilgrims from all over Europe travel to this holy place.

Let's go!

It's only a six-month walk!

The pilgrims make stops at villages like Conques, in southern France. The Church of Saint Foy (Saint Faith) is begun around 1050 to accommodate them.

Ah, here's Conques at last!

Saint Faith, pray for us!

The colored tympanum above the doors, 12 feet (3.7 meters) high and 22 feet (6.7 meters) wide, is a masterpiece of Romanesque art with 124 figures.

It's the Last Judgment! It's frightening!

O peccatores transmutetis nisi mores judicium durum vobis scitote futurum.*

Everything is arranged around the figure of Christ, who is larger than the sinners!

On the left is order; on the right, chaos!

*Sinners, know that if you do not change your ways, you will face harsh judgment!

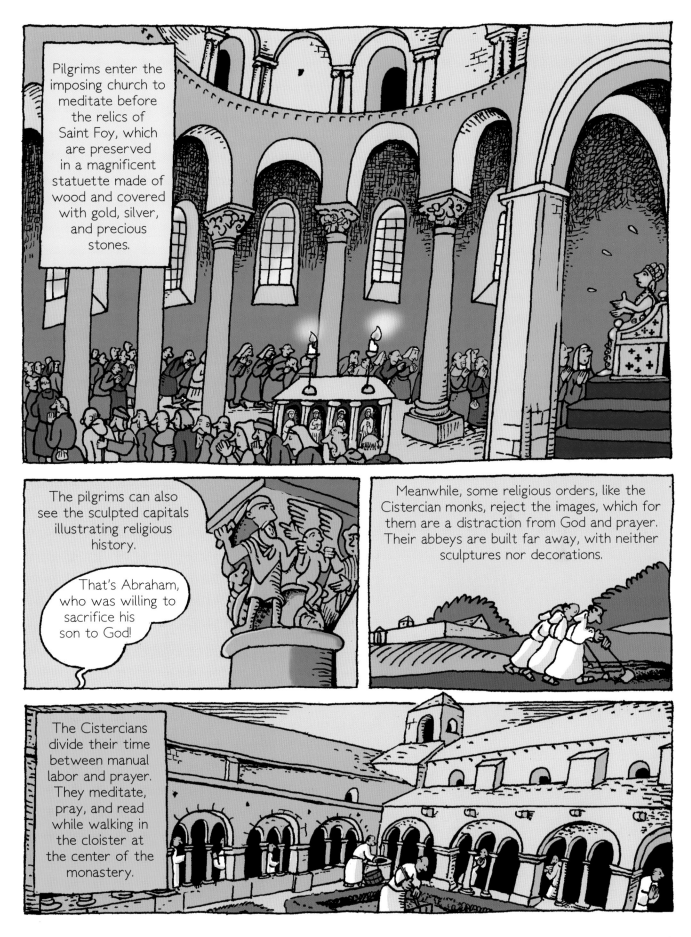

Pilgrims enter the imposing church to meditate before the relics of Saint Foy, which are preserved in a magnificent statuette made of wood and covered with gold, silver, and precious stones.

The pilgrims can also see the sculpted capitals illustrating religious history.

That's Abraham, who was willing to sacrifice his son to God!

Meanwhile, some religious orders, like the Cistercian monks, reject the images, which for them are a distraction from God and prayer. Their abbeys are built far away, with neither sculptures nor decorations.

The Cistercians divide their time between manual labor and prayer. They meditate, pray, and read while walking in the cloister at the center of the monastery.

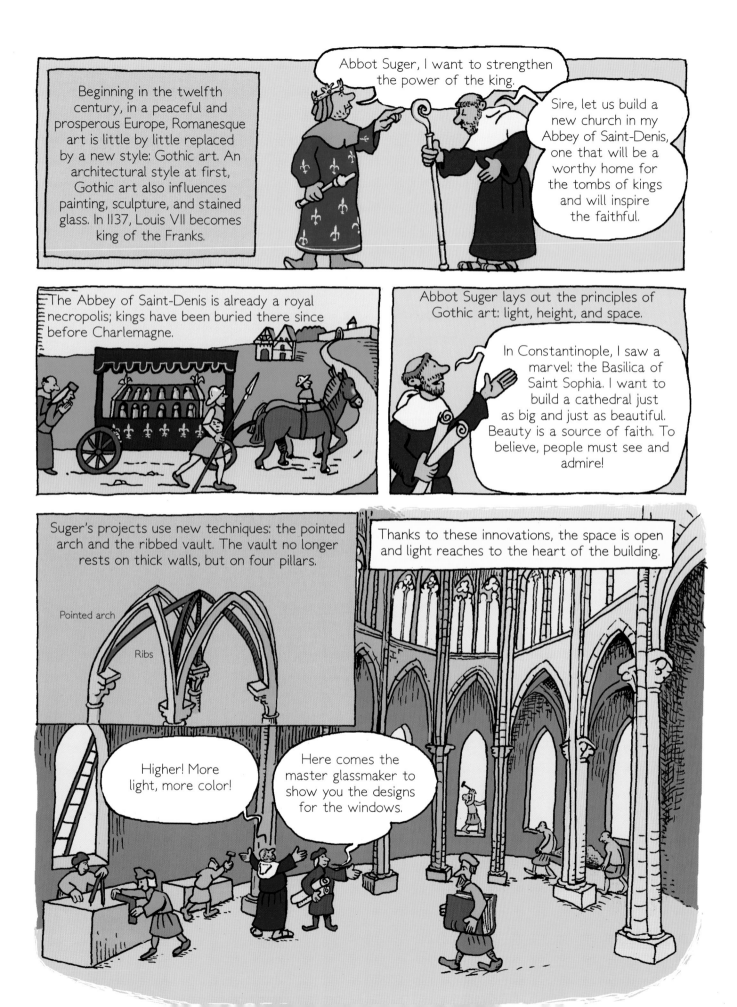

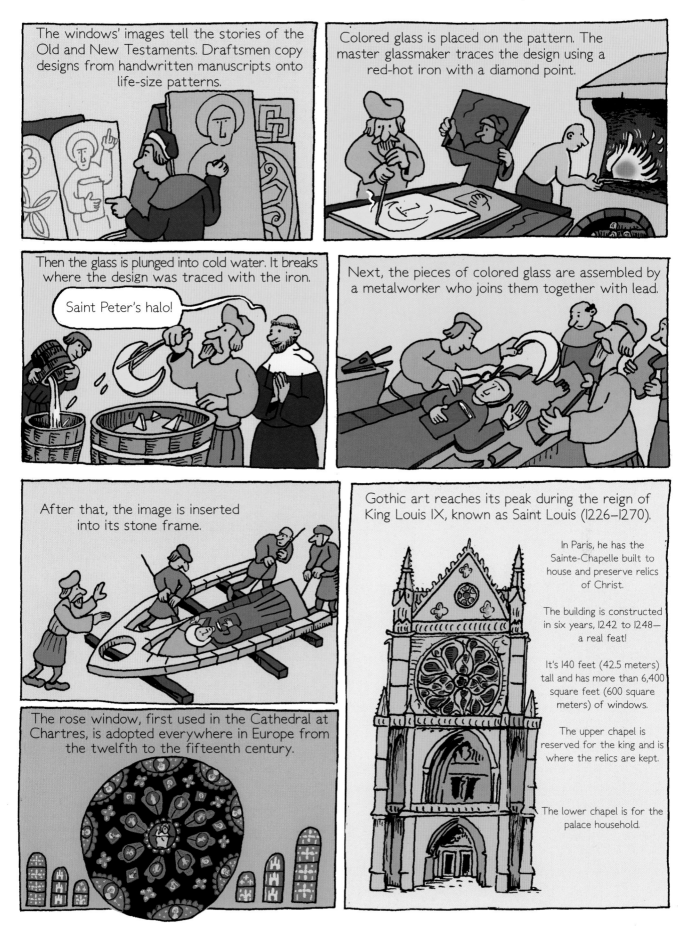

The windows' images tell the stories of the Old and New Testaments. Draftsmen copy designs from handwritten manuscripts onto life-size patterns.

Colored glass is placed on the pattern. The master glassmaker traces the design using a red-hot iron with a diamond point.

Then the glass is plunged into cold water. It breaks where the design was traced with the iron.

Saint Peter's halo!

Next, the pieces of colored glass are assembled by a metalworker who joins them together with lead.

After that, the image is inserted into its stone frame.

The rose window, first used in the Cathedral at Chartres, is adopted everywhere in Europe from the twelfth to the fifteenth century.

Gothic art reaches its peak during the reign of King Louis IX, known as Saint Louis (1226–1270).

In Paris, he has the Sainte-Chapelle built to house and preserve relics of Christ.

The building is constructed in six years, 1242 to 1248— a real feat!

It's 140 feet (42.5 meters) tall and has more than 6,400 square feet (600 square meters) of windows.

The upper chapel is reserved for the king and is where the relics are kept.

The lower chapel is for the palace household.

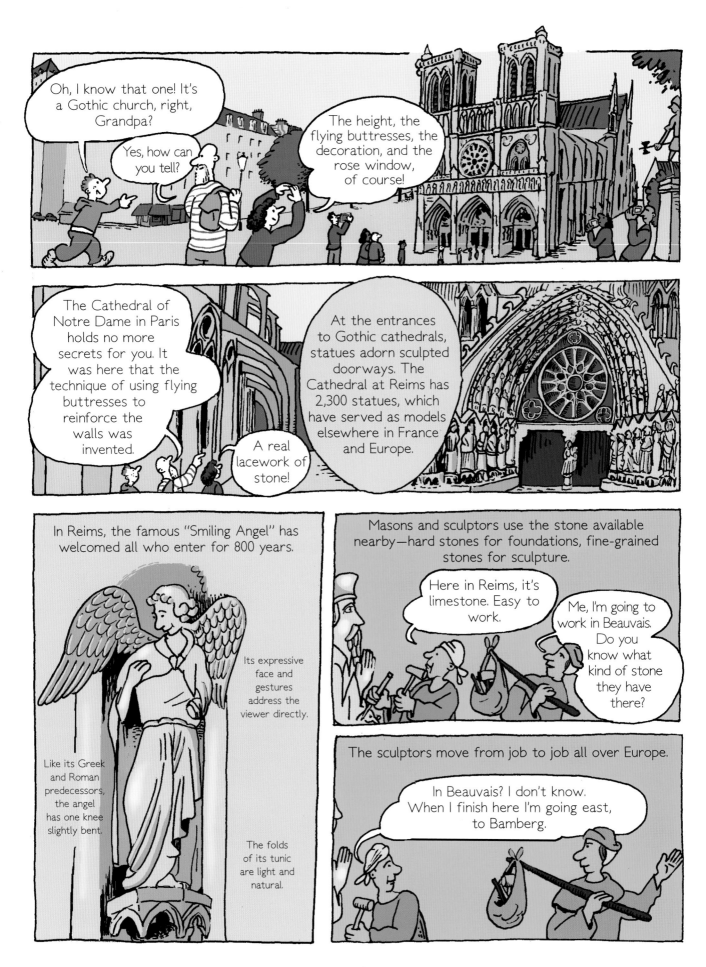

Oh, I know that one! It's a Gothic church, right, Grandpa?

Yes, how can you tell?

The height, the flying buttresses, the decoration, and the rose window, of course!

The Cathedral of Notre Dame in Paris holds no more secrets for you. It was here that the technique of using flying buttresses to reinforce the walls was invented.

A real lacework of stone!

At the entrances to Gothic cathedrals, statues adorn sculpted doorways. The Cathedral at Reims has 2,300 statues, which have served as models elsewhere in France and Europe.

In Reims, the famous "Smiling Angel" has welcomed all who enter for 800 years.

Its expressive face and gestures address the viewer directly.

Like its Greek and Roman predecessors, the angel has one knee slightly bent.

The folds of its tunic are light and natural.

Masons and sculptors use the stone available nearby—hard stones for foundations, fine-grained stones for sculpture.

Here in Reims, it's limestone. Easy to work.

Me, I'm going to work in Beauvais. Do you know what kind of stone they have there?

The sculptors move from job to job all over Europe.

In Beauvais? I don't know. When I finish here I'm going east, to Bamberg.

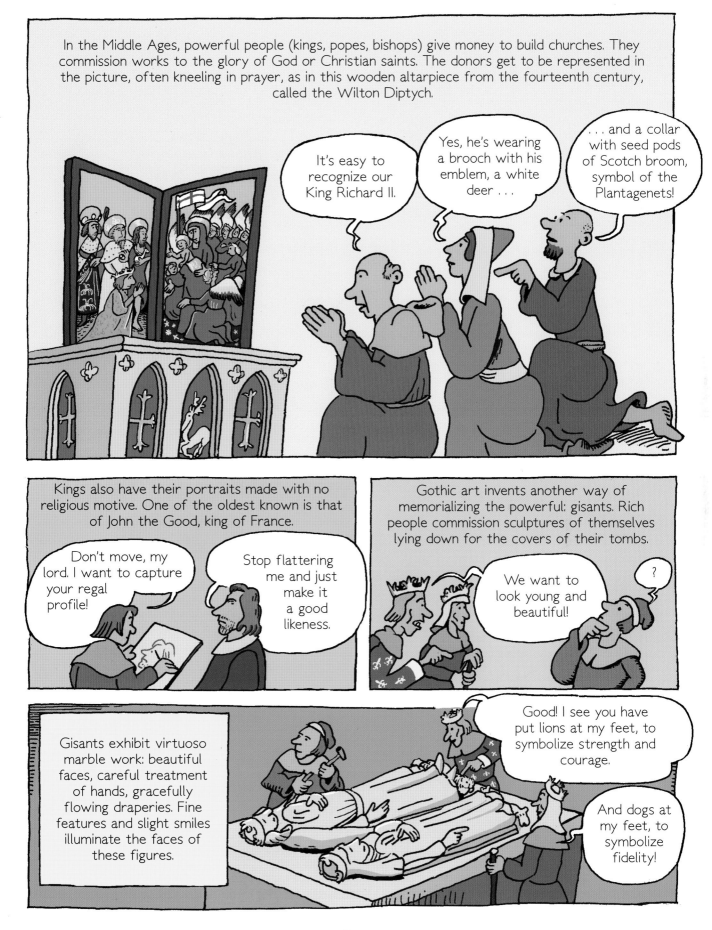

In the Middle Ages, powerful people (kings, popes, bishops) give money to build churches. They commission works to the glory of God or Christian saints. The donors get to be represented in the picture, often kneeling in prayer, as in this wooden altarpiece from the fourteenth century, called the Wilton Diptych.

It's easy to recognize our King Richard II.

Yes, he's wearing a brooch with his emblem, a white deer . . .

. . . and a collar with seed pods of Scotch broom, symbol of the Plantagenets!

Kings also have their portraits made with no religious motive. One of the oldest known is that of John the Good, king of France.

Don't move, my lord. I want to capture your regal profile!

Stop flattering me and just make it a good likeness.

Gothic art invents another way of memorializing the powerful: gisants. Rich people commission sculptures of themselves lying down for the covers of their tombs.

We want to look young and beautiful!

?

Gisants exhibit virtuoso marble work: beautiful faces, careful treatment of hands, gracefully flowing draperies. Fine features and slight smiles illuminate the faces of these figures.

Good! I see you have put lions at my feet, to symbolize strength and courage.

And dogs at my feet, to symbolize fidelity!

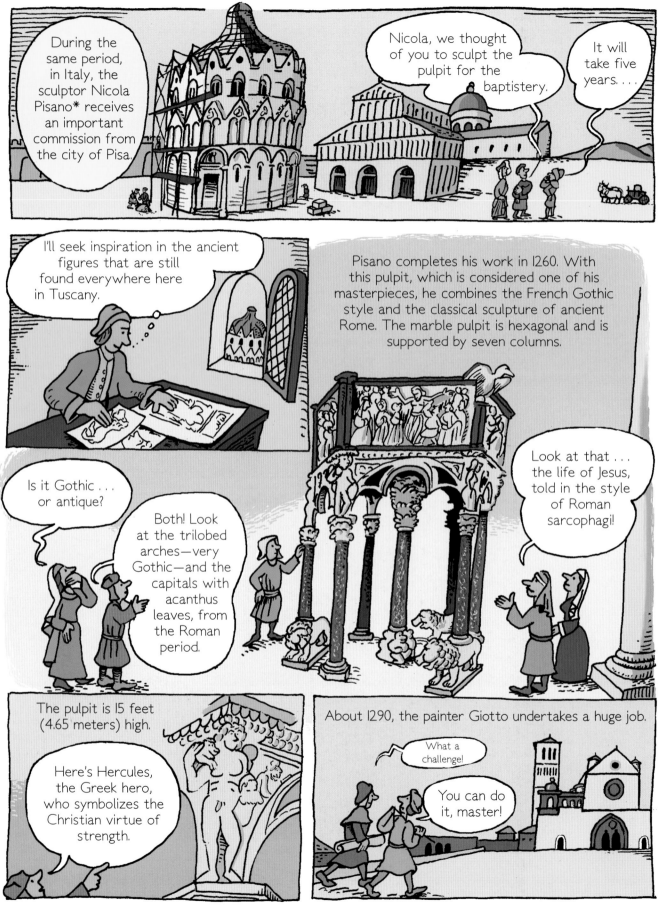

*Nicola Pisano, Italian sculptor (c. 1225–1280)

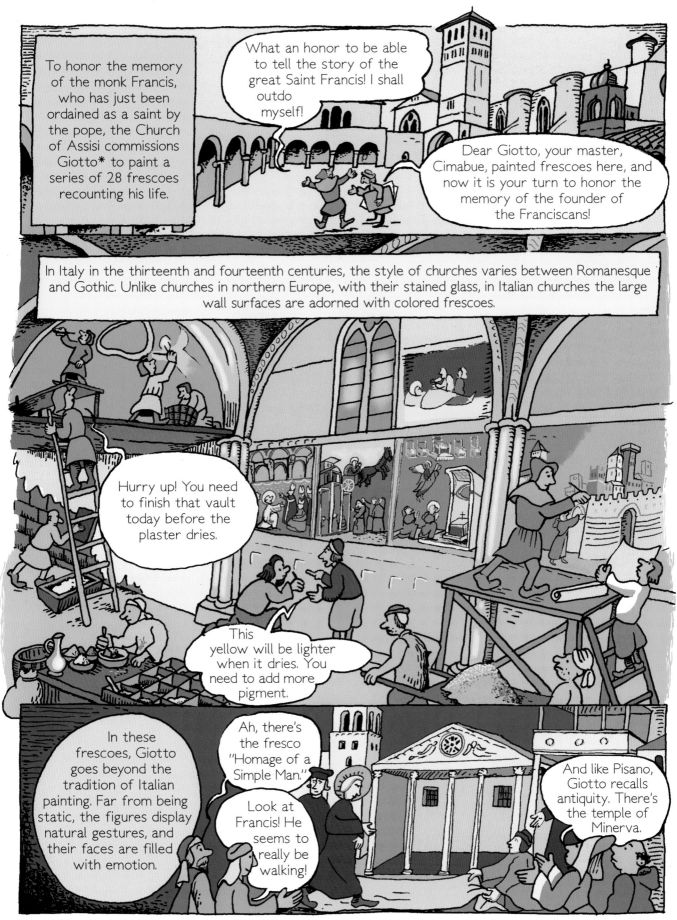

To honor the memory of the monk Francis, who has just been ordained as a saint by the pope, the Church of Assisi commissions Giotto* to paint a series of 28 frescoes recounting his life.

What an honor to be able to tell the story of the great Saint Francis! I shall outdo myself!

Dear Giotto, your master, Cimabue, painted frescoes here, and now it is your turn to honor the memory of the founder of the Franciscans!

In Italy in the thirteenth and fourteenth centuries, the style of churches varies between Romanesque and Gothic. Unlike churches in northern Europe, with their stained glass, in Italian churches the large wall surfaces are adorned with colored frescoes.

Hurry up! You need to finish that vault today before the plaster dries.

This yellow will be lighter when it dries. You need to add more pigment.

In these frescoes, Giotto goes beyond the tradition of Italian painting. Far from being static, the figures display natural gestures, and their faces are filled with emotion.

Ah, there's the fresco "Homage of a Simple Man."

Look at Francis! He seems to really be walking!

And like Pisano, Giotto recalls antiquity. There's the temple of Minerva.

*Giotto di Bondone, Italian sculptor and painter (1267–1337)

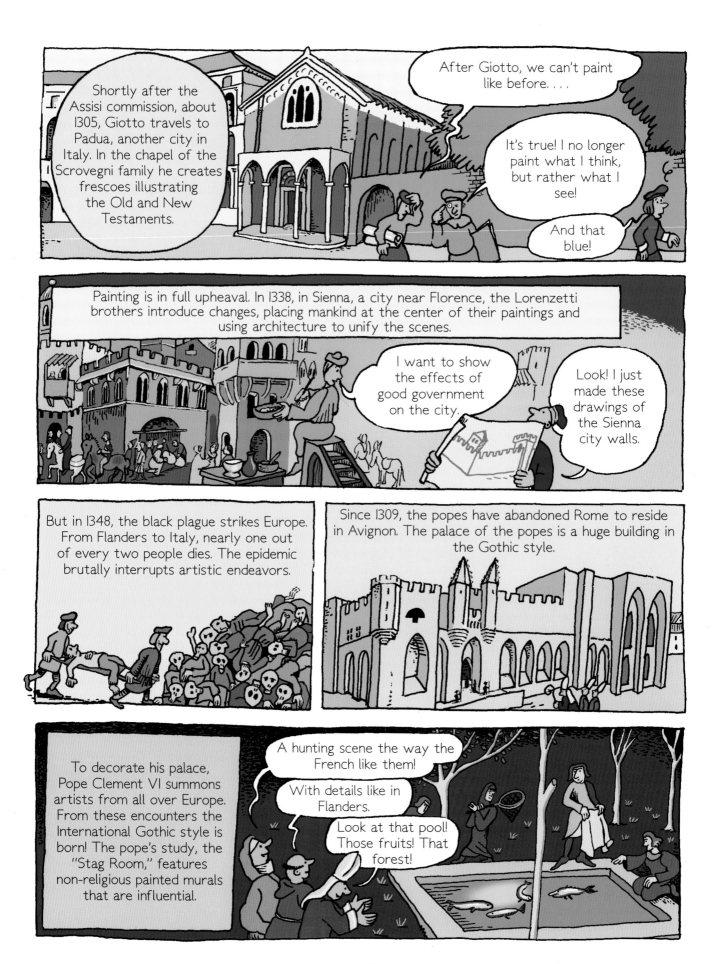

Shortly after the Assisi commission, about 1305, Giotto travels to Padua, another city in Italy. In the chapel of the Scrovegni family he creates frescoes illustrating the Old and New Testaments.

After Giotto, we can't paint like before. . . .

It's true! I no longer paint what I think, but rather what I see!

And that blue!

Painting is in full upheaval. In 1338, in Sienna, a city near Florence, the Lorenzetti brothers introduce changes, placing mankind at the center of their paintings and using architecture to unify the scenes.

I want to show the effects of good government on the city.

Look! I just made these drawings of the Sienna city walls.

But in 1348, the black plague strikes Europe. From Flanders to Italy, nearly one out of every two people dies. The epidemic brutally interrupts artistic endeavors.

Since 1309, the popes have abandoned Rome to reside in Avignon. The palace of the popes is a huge building in the Gothic style.

To decorate his palace, Pope Clement VI summons artists from all over Europe. From these encounters the International Gothic style is born! The pope's study, the "Stag Room," features non-religious painted murals that are influential.

A hunting scene the way the French like them!

With details like in Flanders.

Look at that pool! Those fruits! That forest!

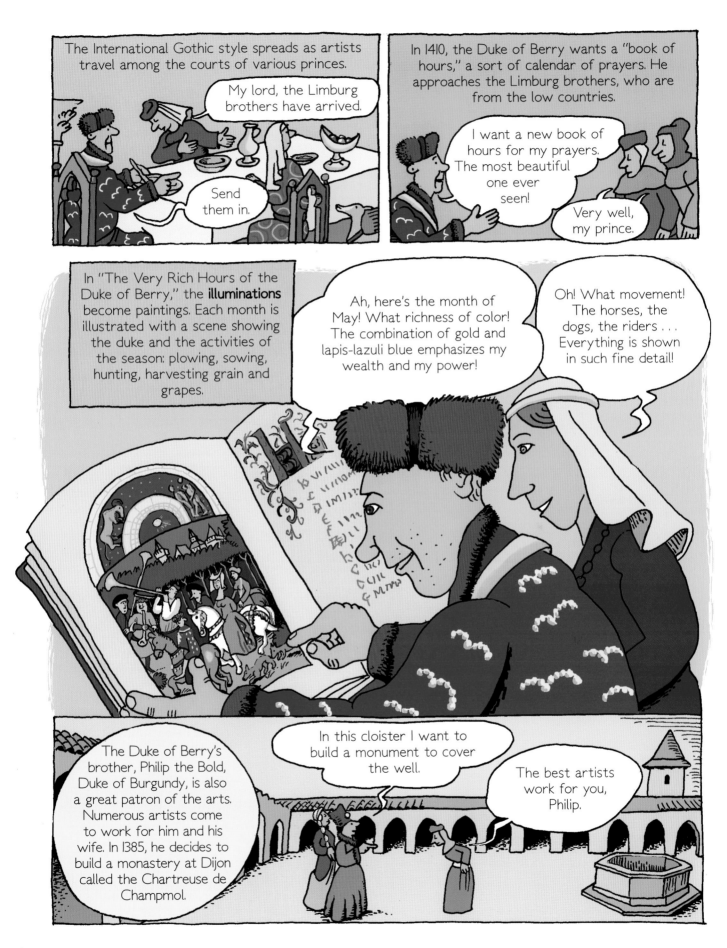

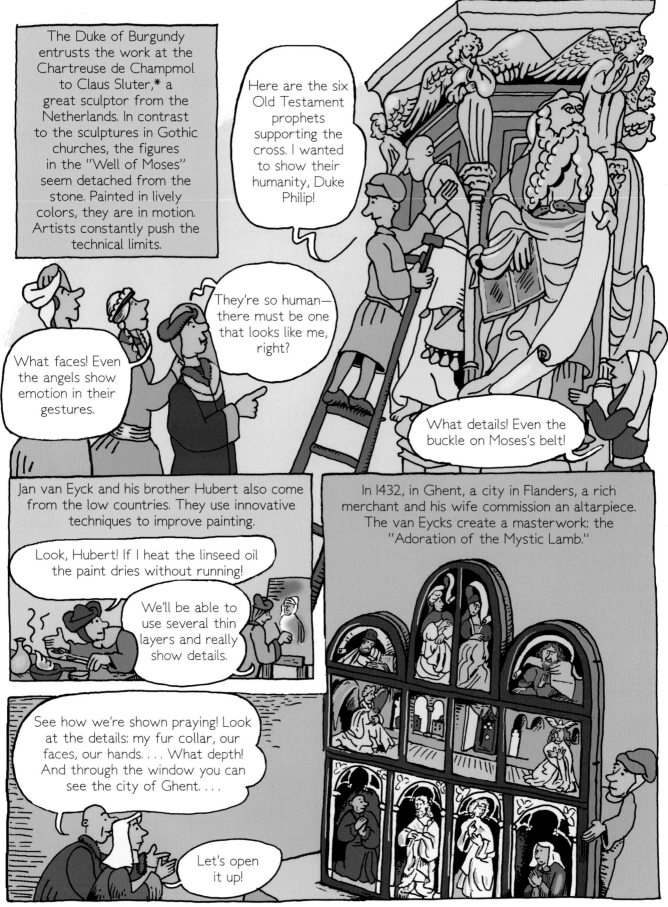

The Duke of Burgundy entrusts the work at the Chartreuse de Champmol to Claus Sluter,* a great sculptor from the Netherlands. In contrast to the sculptures in Gothic churches, the figures in the "Well of Moses" seem detached from the stone. Painted in lively colors, they are in motion. Artists constantly push the technical limits.

Here are the six Old Testament prophets supporting the cross. I wanted to show their humanity, Duke Philip!

What faces! Even the angels show emotion in their gestures.

They're so human—there must be one that looks like me, right?

What details! Even the buckle on Moses's belt!

Jan van Eyck and his brother Hubert also come from the low countries. They use innovative techniques to improve painting.

Look, Hubert! If I heat the linseed oil the paint dries without running!

We'll be able to use several thin layers and really show details.

In 1432, in Ghent, a city in Flanders, a rich merchant and his wife commission an altarpiece. The van Eycks create a masterwork: the "Adoration of the Mystic Lamb."

See how we're shown praying! Look at the details: my fur collar, our faces, our hands.... What depth! And through the window you can see the city of Ghent....

Let's open it up!

*Claus Sluter, Dutch sculptor (c. 1355–1406)

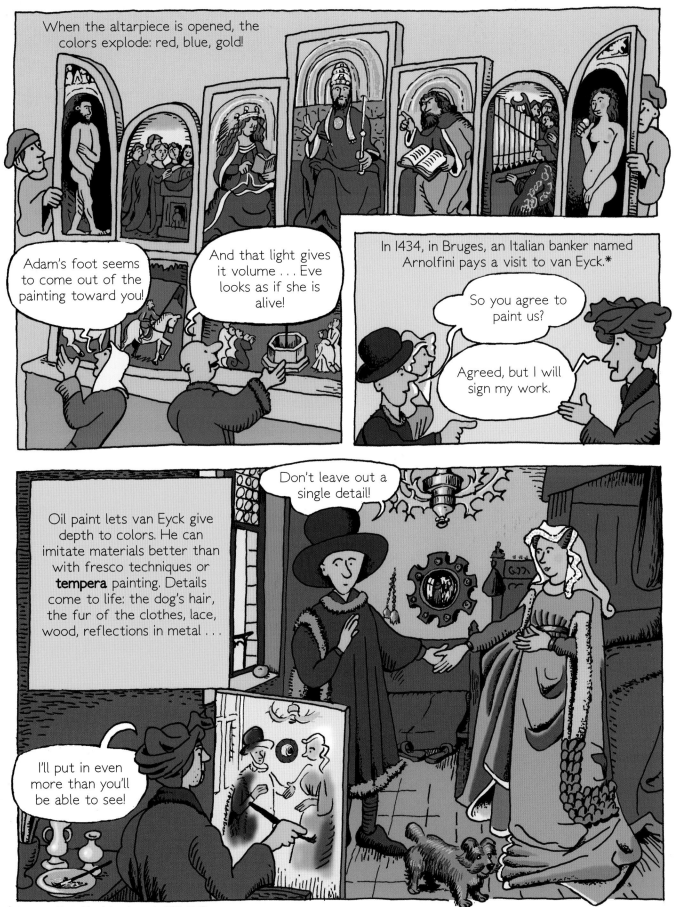

When the altarpiece is opened, the colors explode: red, blue, gold!

Adam's foot seems to come out of the painting toward you!

And that light gives it volume . . . Eve looks as if she is alive!

In 1434, in Bruges, an Italian banker named Arnolfini pays a visit to van Eyck.*

So you agree to paint us?

Agreed, but I will sign my work.

Oil paint lets van Eyck give depth to colors. He can imitate materials better than with fresco techniques or **tempera** painting. Details come to life: the dog's hair, the fur of the clothes, lace, wood, reflections in metal . . .

Don't leave out a single detail!

I'll put in even more than you'll be able to see!

*Jan van Eyck, Flemish painter (c. 1390–1441)

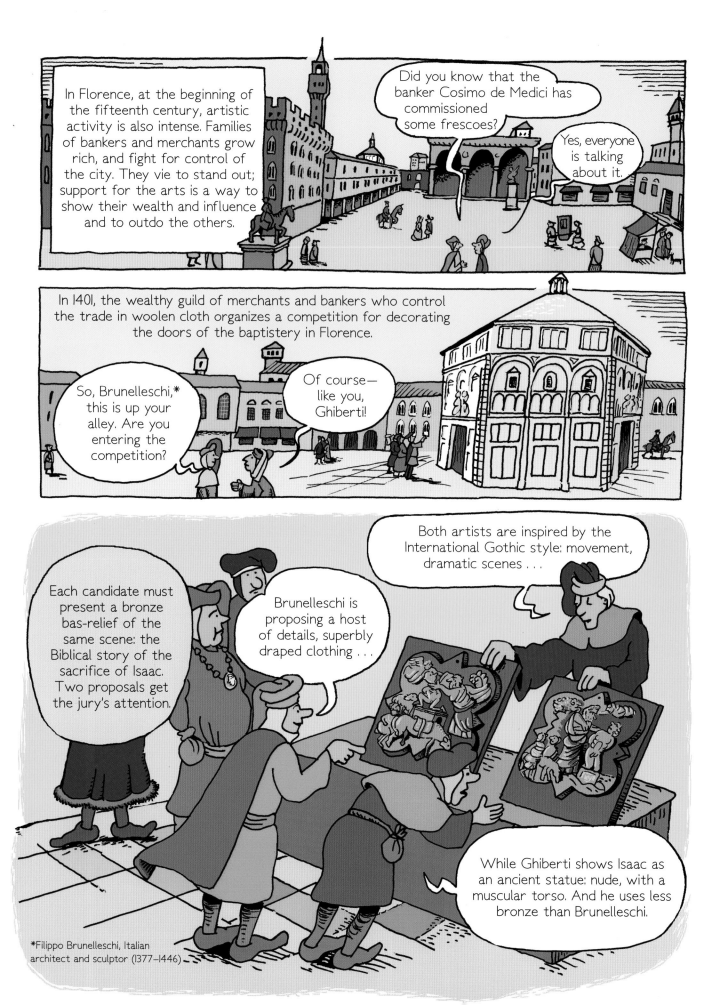

In Florence, at the beginning of the fifteenth century, artistic activity is also intense. Families of bankers and merchants grow rich, and fight for control of the city. They vie to stand out; support for the arts is a way to show their wealth and influence and to outdo the others.

Did you know that the banker Cosimo de Medici has commissioned some frescoes?

Yes, everyone is talking about it.

In 1401, the wealthy guild of merchants and bankers who control the trade in woolen cloth organizes a competition for decorating the doors of the baptistery in Florence.

So, Brunelleschi,* this is up your alley. Are you entering the competition?

Of course— like you, Ghiberti!

Each candidate must present a bronze bas-relief of the same scene: the Biblical story of the sacrifice of Isaac. Two proposals get the jury's attention.

Brunelleschi is proposing a host of details, superbly draped clothing . . .

Both artists are inspired by the International Gothic style: movement, dramatic scenes . . .

While Ghiberti shows Isaac as an ancient statue: nude, with a muscular torso. And he uses less bronze than Brunelleschi.

*Filippo Brunelleschi, Italian architect and sculptor (1377–1446)

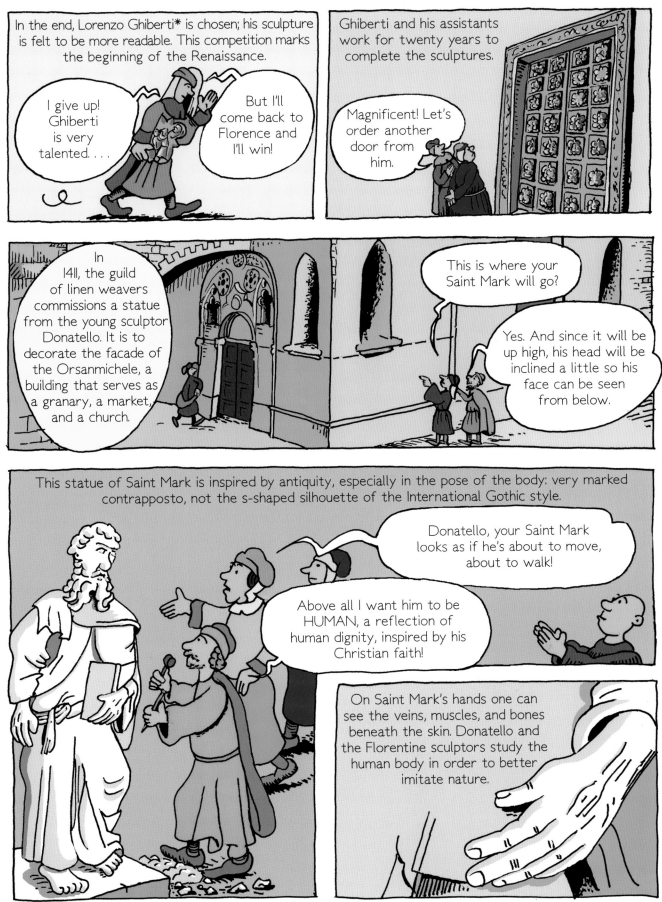

In the end, Lorenzo Ghiberti* is chosen; his sculpture is felt to be more readable. This competition marks the beginning of the Renaissance.

I give up! Ghiberti is very talented. . . .

But I'll come back to Florence and I'll win!

Ghiberti and his assistants work for twenty years to complete the sculptures.

Magnificent! Let's order another door from him.

In 1411, the guild of linen weavers commissions a statue from the young sculptor Donatello. It is to decorate the facade of the Orsanmichele, a building that serves as a granary, a market, and a church.

This is where your Saint Mark will go?

Yes. And since it will be up high, his head will be inclined a little so his face can be seen from below.

This statue of Saint Mark is inspired by antiquity, especially in the pose of the body: very marked contrapposto, not the s-shaped silhouette of the International Gothic style.

Donatello, your Saint Mark looks as if he's about to move, about to walk!

Above all I want him to be HUMAN, a reflection of human dignity, inspired by his Christian faith!

On Saint Mark's hands one can see the veins, muscles, and bones beneath the skin. Donatello and the Florentine sculptors study the human body in order to better imitate nature.

*Lorenzo Ghiberti, Italian architect and sculptor (1378–1455)

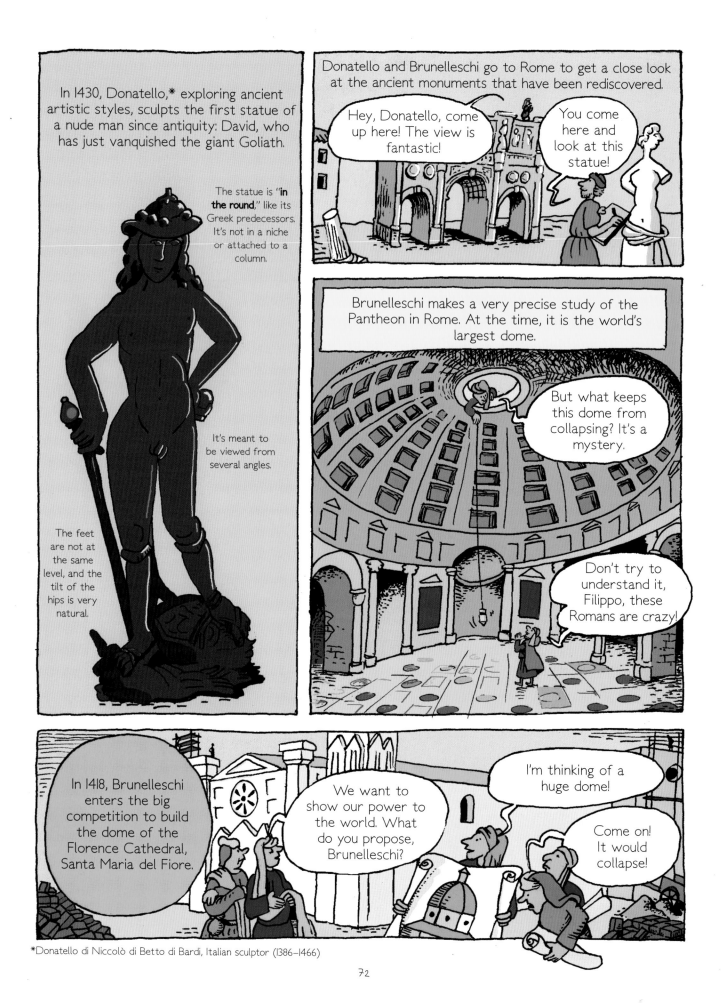

In 1430, Donatello,* exploring ancient artistic styles, sculpts the first statue of a nude man since antiquity: David, who has just vanquished the giant Goliath.

The statue is "**in the round**," like its Greek predecessors. It's not in a niche or attached to a column.

It's meant to be viewed from several angles.

The feet are not at the same level, and the tilt of the hips is very natural.

Donatello and Brunelleschi go to Rome to get a close look at the ancient monuments that have been rediscovered.

Hey, Donatello, come up here! The view is fantastic!

You come here and look at this statue!

Brunelleschi makes a very precise study of the Pantheon in Rome. At the time, it is the world's largest dome.

But what keeps this dome from collapsing? It's a mystery.

Don't try to understand it, Filippo, these Romans are crazy!

In 1418, Brunelleschi enters the big competition to build the dome of the Florence Cathedral, Santa Maria del Fiore.

We want to show our power to the world. What do you propose, Brunelleschi?

I'm thinking of a huge dome!

Come on! It would collapse!

*Donatello di Niccolò di Betto di Bardi, Italian sculptor (1386–1466)

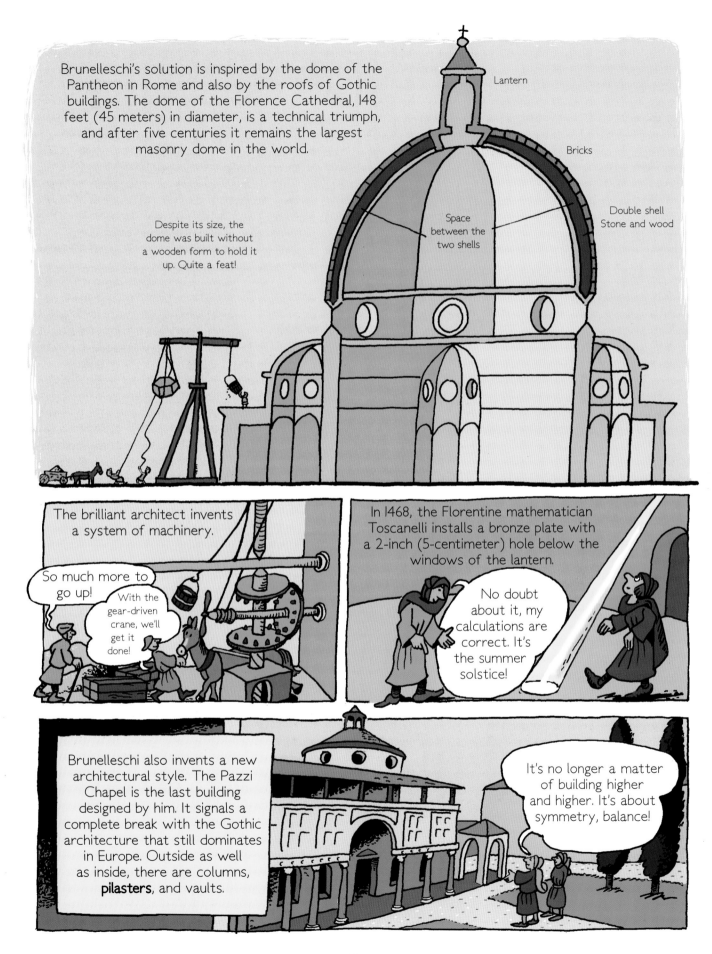

Brunelleschi's solution is inspired by the dome of the Pantheon in Rome and also by the roofs of Gothic buildings. The dome of the Florence Cathedral, 148 feet (45 meters) in diameter, is a technical triumph, and after five centuries it remains the largest masonry dome in the world.

Lantern

Bricks

Double shell
Stone and wood

Space between the two shells

Despite its size, the dome was built without a wooden form to hold it up. Quite a feat!

The brilliant architect invents a system of machinery.

So much more to go up!

With the gear-driven crane, we'll get it done!

In 1468, the Florentine mathematician Toscanelli installs a bronze plate with a 2-inch (5-centimeter) hole below the windows of the lantern.

No doubt about it, my calculations are correct. It's the summer solstice!

Brunelleschi also invents a new architectural style. The Pazzi Chapel is the last building designed by him. It signals a complete break with the Gothic architecture that still dominates in Europe. Outside as well as inside, there are columns, **pilasters**, and vaults.

It's no longer a matter of building higher and higher. It's about symmetry, balance!

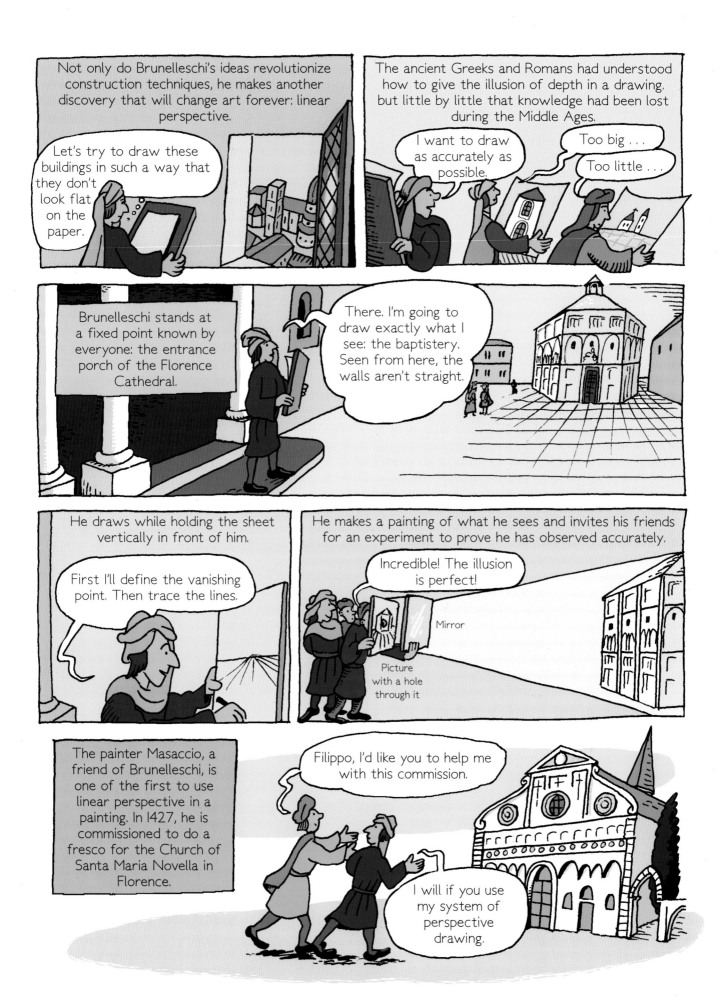

For the large fresco (more than 20 feet by 10 feet / 6 meters by 3 meters), Masaccio* chooses a classic theme: the Trinity. At the top is God; next is the Holy Spirit, represented by a dove; and then Jesus on the cross. Yet the way the figures are presented is totally new: they are painted from the point of view of the spectator and are all the same size.

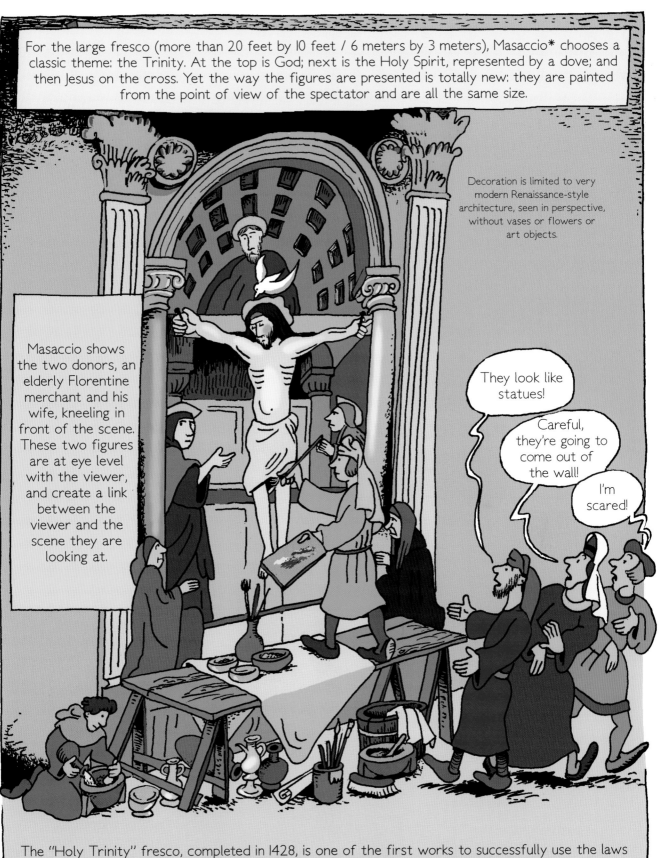

The "Holy Trinity" fresco, completed in 1428, is one of the first works to successfully use the laws of perspective. It is a major influence on all the painters who come to study it.

*Masaccio, Italian painter (1401–1428)

75

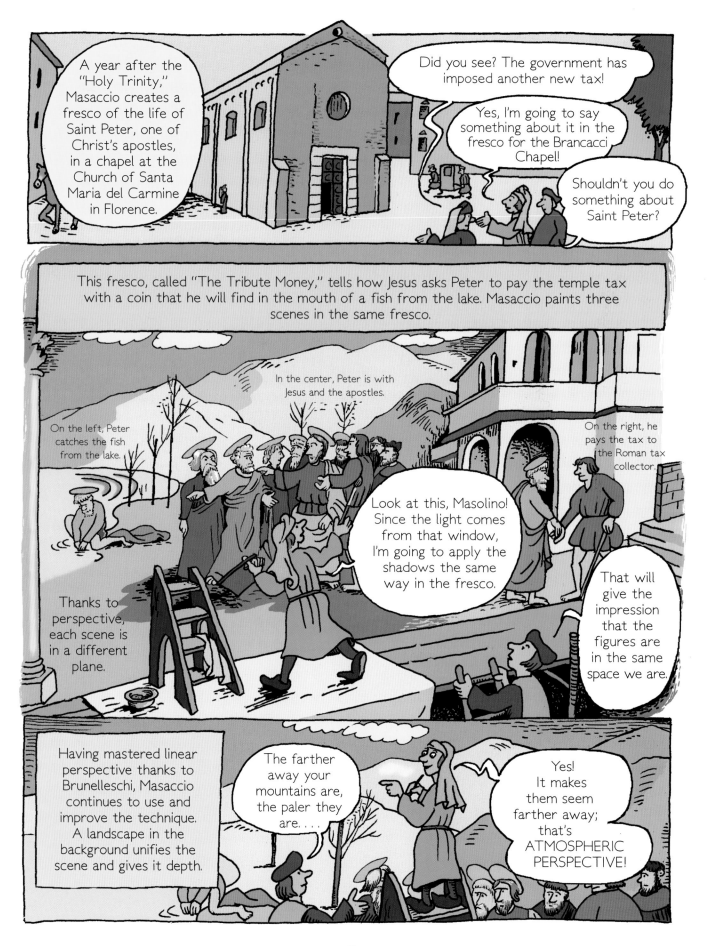

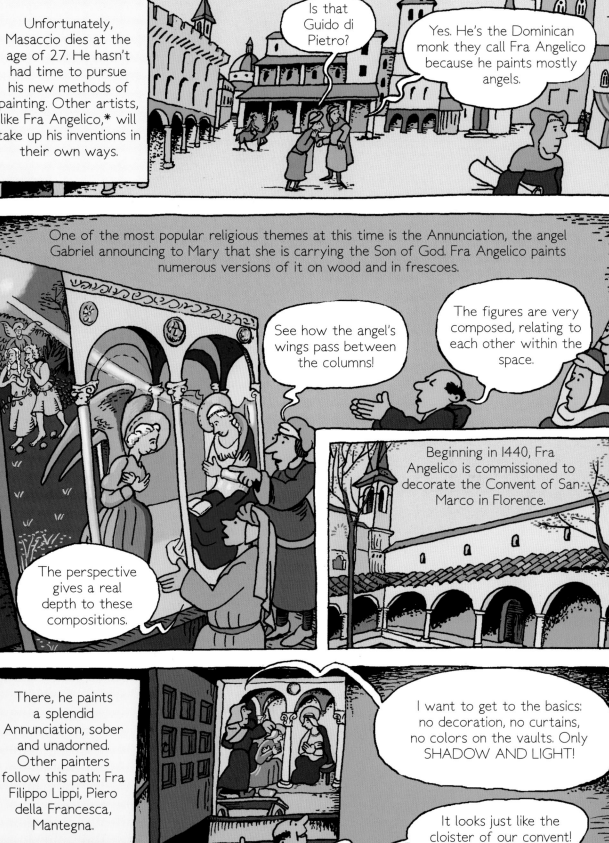

Unfortunately, Masaccio dies at the age of 27. He hasn't had time to pursue his new methods of painting. Other artists, like Fra Angelico,* will take up his inventions in their own ways.

Is that Guido di Pietro?

Yes. He's the Dominican monk they call Fra Angelico because he paints mostly angels.

One of the most popular religious themes at this time is the Annunciation, the angel Gabriel announcing to Mary that she is carrying the Son of God. Fra Angelico paints numerous versions of it on wood and in frescoes.

See how the angel's wings pass between the columns!

The figures are very composed, relating to each other within the space.

The perspective gives a real depth to these compositions.

Beginning in 1440, Fra Angelico is commissioned to decorate the Convent of San Marco in Florence.

There, he paints a splendid Annunciation, sober and unadorned. Other painters follow this path: Fra Filippo Lippi, Piero della Francesca, Mantegna.

I want to get to the basics: no decoration, no curtains, no colors on the vaults. Only SHADOW AND LIGHT!

It looks just like the cloister of our convent!

*Fra Angelico, Italian painter (c. 1395–1455)

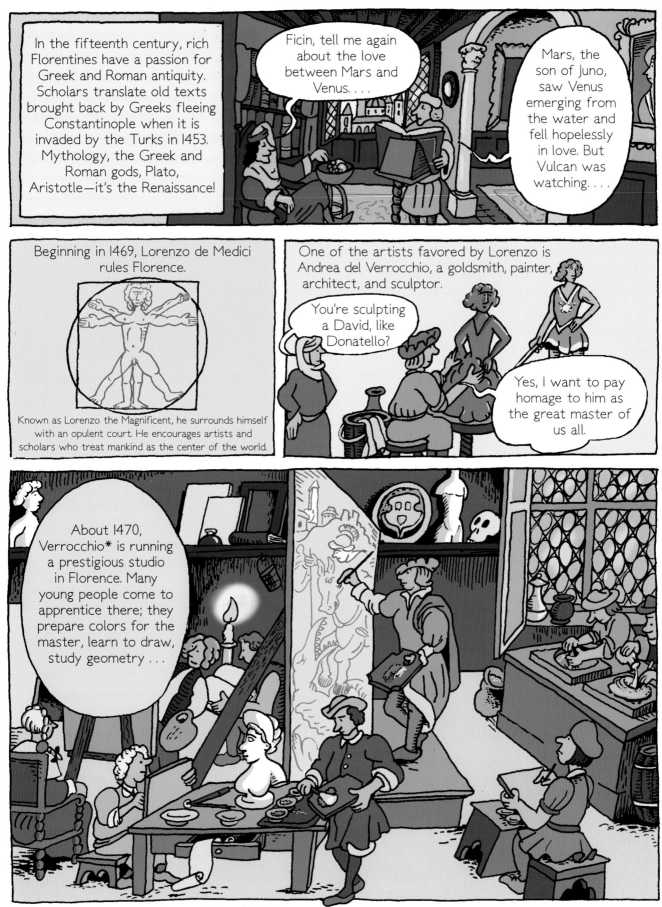

In the fifteenth century, rich Florentines have a passion for Greek and Roman antiquity. Scholars translate old texts brought back by Greeks fleeing Constantinople when it is invaded by the Turks in 1453. Mythology, the Greek and Roman gods, Plato, Aristotle—it's the Renaissance!

Ficin, tell me again about the love between Mars and Venus. . . .

Mars, the son of Juno, saw Venus emerging from the water and fell hopelessly in love. But Vulcan was watching. . . .

Beginning in 1469, Lorenzo de Medici rules Florence.

Known as Lorenzo the Magnificent, he surrounds himself with an opulent court. He encourages artists and scholars who treat mankind as the center of the world.

One of the artists favored by Lorenzo is Andrea del Verrocchio, a goldsmith, painter, architect, and sculptor.

You're sculpting a David, like Donatello?

Yes, I want to pay homage to him as the great master of us all.

About 1470, Verrocchio* is running a prestigious studio in Florence. Many young people come to apprentice there; they prepare colors for the master, learn to draw, study geometry . . .

*Andrea del Verrocchio, Italian sculptor and painter (1435–1488)

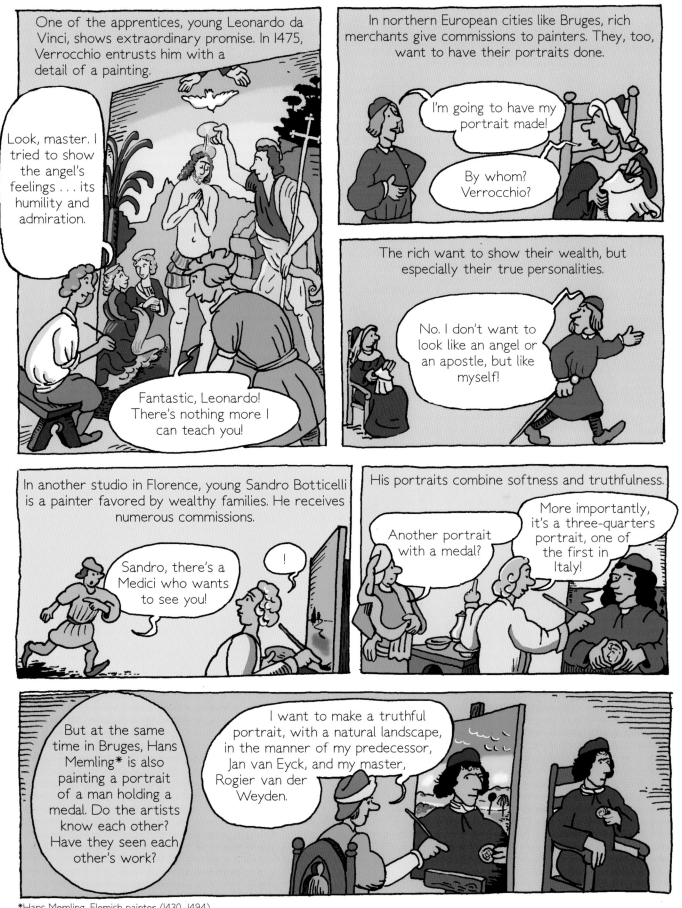

One of the apprentices, young Leonardo da Vinci, shows extraordinary promise. In 1475, Verrocchio entrusts him with a detail of a painting.

Look, master. I tried to show the angel's feelings . . . its humility and admiration.

Fantastic, Leonardo! There's nothing more I can teach you!

In northern European cities like Bruges, rich merchants give commissions to painters. They, too, want to have their portraits done.

I'm going to have my portrait made!

By whom? Verrocchio?

The rich want to show their wealth, but especially their true personalities.

No. I don't want to look like an angel or an apostle, but like myself!

In another studio in Florence, young Sandro Botticelli is a painter favored by wealthy families. He receives numerous commissions.

Sandro, there's a Medici who wants to see you!

!

His portraits combine softness and truthfulness.

Another portrait with a medal?

More importantly, it's a three-quarters portrait, one of the first in Italy!

But at the same time in Bruges, Hans Memling* is also painting a portrait of a man holding a medal. Do the artists know each other? Have they seen each other's work?

I want to make a truthful portrait, with a natural landscape, in the manner of my predecessor, Jan van Eyck, and my master, Rogier van der Weyden.

*Hans Memling, Flemish painter (1430–1494)

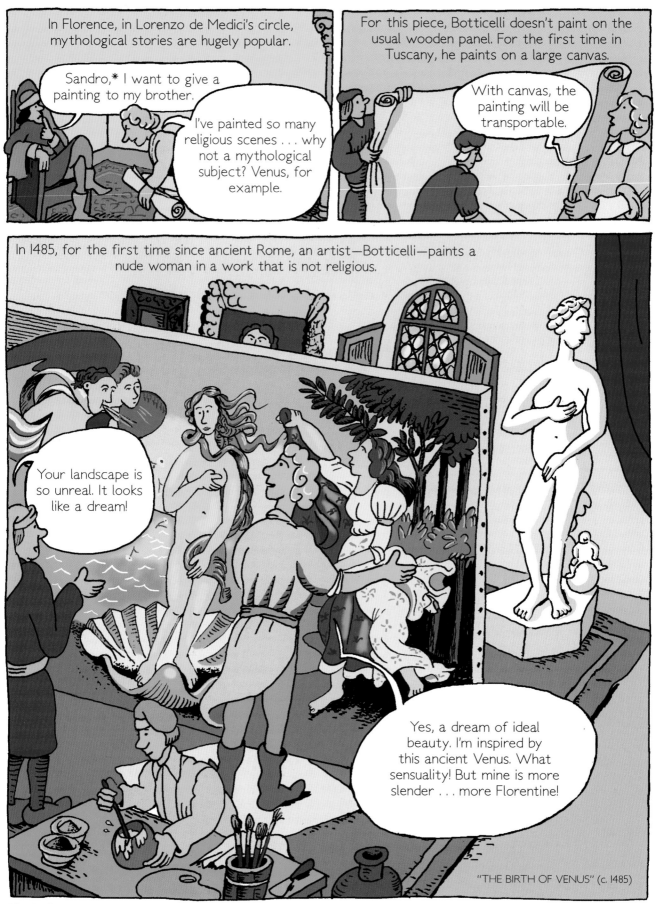

In Florence, in Lorenzo de Medici's circle, mythological stories are hugely popular.

Sandro,* I want to give a painting to my brother.

I've painted so many religious scenes . . . why not a mythological subject? Venus, for example.

For this piece, Botticelli doesn't paint on the usual wooden panel. For the first time in Tuscany, he paints on a large canvas.

With canvas, the painting will be transportable.

In 1485, for the first time since ancient Rome, an artist—Botticelli—paints a nude woman in a work that is not religious.

Your landscape is so unreal. It looks like a dream!

Yes, a dream of ideal beauty. I'm inspired by this ancient Venus. What sensuality! But mine is more slender . . . more Florentine!

"THE BIRTH OF VENUS" (c. 1485)

*Sandro Botticelli, Italian painter (1445–1510)

The Art of Prehistory

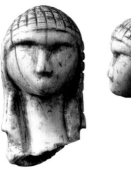

The Venus of Brassempouy

Also called the Lady with the Hood because of the shape of her hairstyle, she was found in the Pope's Cave at Brassempouy in southwestern France. Made of mammoth ivory, and 1.5 inches (3.6 centimeters) tall, she was sculpted more than 22,000 years ago. She is on exhibit at the National Museum of Archaeology in Saint-Germain-en-Laye.

Reindeer Antler Spear-Thrower

This object was found in the rock shelter of La Madeleine in southwestern France, one of the most important sites of the Magdalenian reindeer hunters who lived beside the Vézère River. This weapon, made of reindeer antler, dates from 15000 BCE. It is in the National Museum of Prehistory in Eyzies-de-Tayac, France.

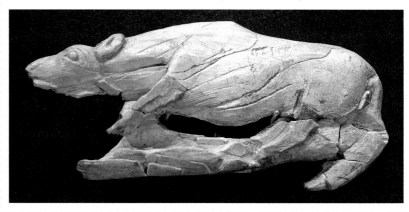

The Venus of Willendorf

Discovered in 1908 in Austria, this limestone statuette is 4.3 inches (11 centimeters) tall. It dates from 29500 BCE, and is exhibited at the Natural History Museum in Vienna.

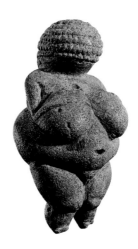

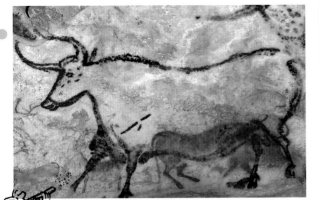

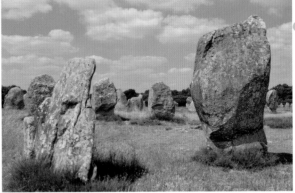

The Lascaux Cave

The number and quality of its paintings make this one of the most important decorated caves of the Paleolithic period. Its paintings and engravings are thought to date from around 18000 BCE.

It is located in the Vézère Valley of southwestern France, not far from the Magdalenian rock shelter. The cave itself is closed to visitors, but you can visit a replica.

The Carnac Stones

At Carnac, in Brittany, there are alignments of imposing stones: more than 3,000 menhirs, dolmens, and covered passages are spread over more than 2.5 miles (4 kilometers). The alignments date from about 4000 to 3500 BCE, in the Neolithic period. They probably had a religious or burial function.

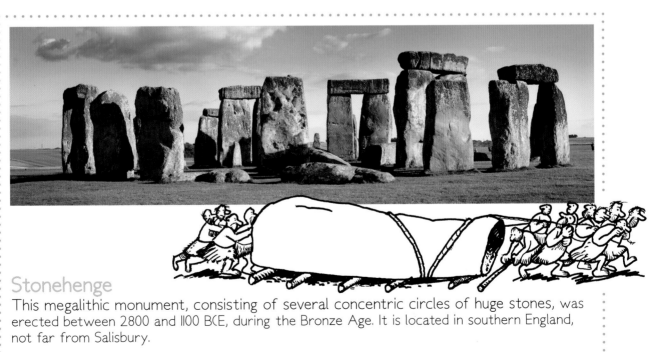

Stonehenge

This megalithic monument, consisting of several concentric circles of huge stones, was erected between 2800 and 1100 BCE, during the Bronze Age. It is located in southern England, not far from Salisbury.

The Art of the Ancient Middle East and Egypt

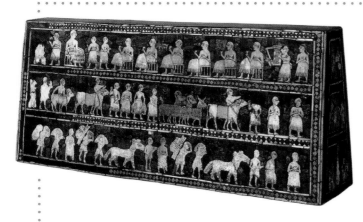

The Standard of Ur

This object, found in the royal cemetery of the ancient city of Ur (in present-day Iraq, south of Baghdad), dates from around 2650 BCE. It is a small wooden box, 11 inches (27 centimeters) high and 19 inches (48 centimeters) long, inlaid with a mosaic of mother-of-pearl, red limestone, and lapis lazuli in four panels. It is on exhibit at the British Museum in London.

The Statue of Ebih-Il

This statue was discovered in a temple at Mari, an ancient city in present-day Syria. Dating from 2340 BCE, this masterpiece of Mesopotamian art shows a man at prayer. It is 21 inches (53 centimeters) tall and is made of gypsum with inlays of lapis lazuli and shell. It can be seen at the Louvre Museum in Paris.

The Code of Hammurabi

An emblem of the Mesopotamian civilization, this tall stele erected by the king of Babylon dates from between 1792 and 1750 BCE. It is both a historical object and a literary work, and is the most complete collection of laws from antiquity. Made of basalt, a very hard black stone, it is 7.4 feet (2.25 meters) tall. It is on display at the Louvre Museum in Paris.

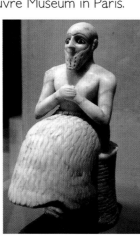

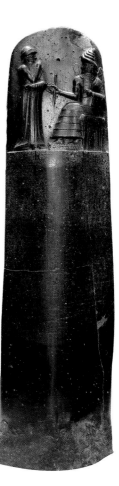

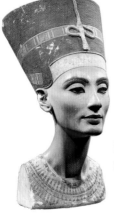

The Bust of Nefertiti

This bust, 20 inches (50 centimeters) tall, was made around 1350 BCE. It was sculpted from limestone then covered with plaster and painted. It was found at Tell el-Amarna, the city founded by the pharaoh Akhenaton, Nefertiti's husband. The queen's face is perfectly symmetrical and is intact except for the left eye, which no longer has its inlay of black-painted quartz. It can be seen at the New Museum in Berlin.

The Pyramids and Sphinx of Giza

On the Giza plain, not far from Cairo, stand the sphinx and the pyramids, among the seven wonders of the ancient world. The site is a former necropolis, used primarily during the Old Kingdom (about 2500 BCE). Carved from limestone, the sphinx is the world's largest sculpture at 240 feet (73 meters) long, 45 feet (14 meters) wide, and 65 feet (20 meters) tall.

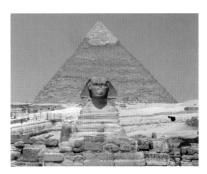

The Seated Scribe

This scribe sitting cross-legged, made of painted limestone, and measuring 21 inches (54 centimeters) tall, is among the masterpieces of ancient art. Dating from between 2600 and 2350 BCE, it comes from Saqqara, south of Cairo. We know nothing about the person depicted—not his name, his status, or the exact period when he lived. The statue is in the Louvre Museum in Paris.

The Art of Ancient Greece

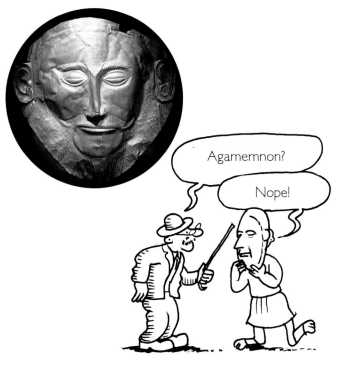

Cycladic Idol

Small marble sculptures like this come from the Cyclades archipelago in Greece. They first appeared about 2500 BCE, on the island of Keros, and depict female figures or flat faces. This one measures 7.5 inches (19 centimeters) tall and is displayed in the Louvre Museum in Paris.

Funeral Mask

This gold mask, once incorrectly attributed to King Agamemnon, was discovered in a tomb at Mycenae in Greece. It is 12 inches (31 centimeters) tall and was placed on the head of a rich nobleman who had died. Dating from about 1500 BCE, the mask is exhibited at the National Archaeological Museum in Athens.

Kouros of Anavyssos

This marble Greek statue dates from the Archaic period (about 540 BCE). It represents a nude young man, or kouros, and is 6 feet, 4 inches (1.94 meters) tall. Such statues had two uses: in temples, they were offerings; in cemeteries, they marked the tombs of important citizens. The kouros of Anavyssos is preserved in the National Archaeological Museum in Athens.

Venus de Milo

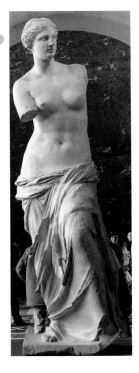

Ever since its discovery on the island of Milos, in the Cyclades, this statue has held a mystery: is it Aphrodite, the Greek goddess of love, or Amphitrite, goddess of the sea? Sculpted in marble around 100 BCE, the 6.5-foot (2-meter) statue is notable for the movement of the body, which turns in a spiral, and in the way the cloth drapes over the hips. It is on exhibit at the Louvre Museum in Paris.

Venus, I love you!

Achilles and Ajax Playing Dice

This large vase, 24 inches (61 centimeters) tall, was created by Exekias, who signed his work. It is from the Athens area and dates from 530 BCE. It is one of the most refined examples of "black figure" ceramics; the figures of the Greek heroes are engraved in very precise detail. It can be seen in Rome at the Vatican's Gregorian Etruscan Museum.

The Parthenon

The Parthenon is situated on the Acropolis—the "high city"—in Athens, Greece. This huge marble edifice was dedicated to Athena Parthenos, protector of the city and goddess of war and wisdom. The Parthenon was built to house the famous gold-and-ivory statue of Athena, the treasure of the city, but the statue has disappeared.

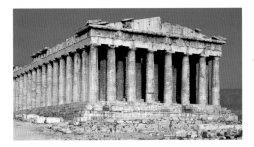

I've been pillaged!

AΘHNA

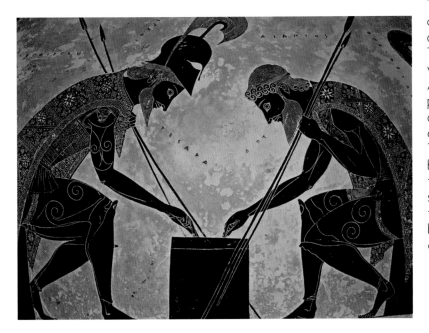

The Art of Ancient Rome

Julius Caesar

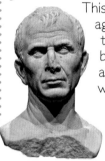

This life-size marble bust of an aging man was recovered from the Rhône River in 2007. It may be a portrait of Julius Caesar and date from 46 BCE, which would make it the oldest known depiction of Caesar. It is on display at the Departmental Museum of Ancient Arles, beside the Rhône in southern France.

Augustus of Prima Porta

This marble statue of Augustus was found in a villa near Prima Porta, north of Rome. Dating from the year 14 CE, it was probably modeled on an older bronze statue. The emperor, shown in the pose of a general addressing his troops, is in the contrapposto pose invented by the Greek sculptor Polyclitus around 440 BCE. The statue is in the Vatican Museums in Rome.

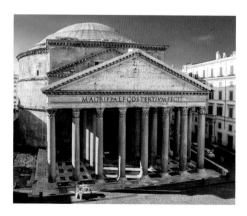

The Pantheon

Originally, the Pantheon in Rome was a temple dedicated to all the divinities of the ancient Roman religion. Built in the 1st century BCE, it was damaged by several fires, entirely rebuilt under the emperor Hadrian, and then converted to a Christian church. Covered by the largest dome in the ancient world (140 feet / 43 meters in diameter), the Pantheon is a major architectural achievement.

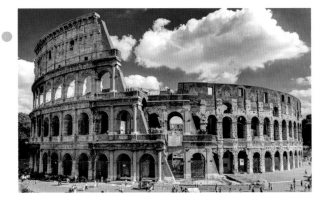

The Colosseum

The Colosseum is a huge amphitheater located in the center of Rome. Holding as many as 75,000 spectators, it was one of the largest works of Roman architecture and engineering. Its construction was completed in 80 CE. Its name is said to come from the colossal statue of the emperor Nero that was erected nearby.

The Alexander Mosaic

This large floor mosaic was discovered at Pompeii in southern Italy. Dating from the end of the 2nd century BCE, it shows Alexander's battle at Issus and may have been inspired by a Greek painting. It was made with about 2 million pieces in only four colors: yellow, red, black, and white. It measures 19 feet (5.8 meters) by 10 feet (3.1 meters), including the frame. It is now on exhibit at the National Archaeological Museum in Naples.

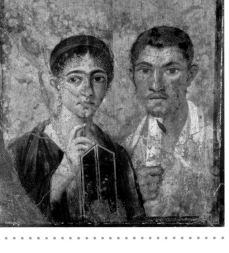

The Baker and his Wife

This fresco by an unknown artist, 26 inches (65 centimeters) high and 23 inches (58 centimeters) wide, shows a middle-class couple from Pompeii, probably husband and wife. It's believed to be of the baker Terentius Neo and his wife. The fresco was painted between 45 and 60 CE, and is preserved in Naples at the archaeological museum.

The Art of the Middle Ages

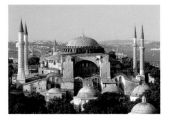

Hagia Sophia

Hagia Sophia (Sophia means "divine wisdom" in Greek) is in Istanbul, Turkey. Built as a Christian church, Saint Sophia, in the 6th century under the emperor Justinian, it became a mosque in the 15th century. This huge, richly decorated building was inspired by the Pantheon in Rome and by Christian basilicas. This style of architecture, called Byzantine, has in turn inspired Arab, Venetian, and Ottoman architects.

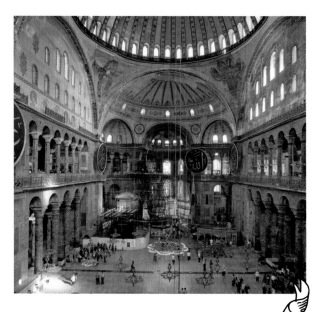

Book of Kells

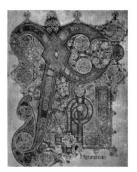

This exceptional manuscript was written in Latin by Celtic monks in Ireland around 800 CE. It is composed of 340 bound parchment pages, or folios, 13 inches (33 centimeters) by 10 inches (25 centimeters). Page 34r (shown) carries the famous monogram formed from the letters X (chi) and P (rho), the first two letters of the word "Christ" in Greek. It is on display at the library of Trinity College in Dublin, Ireland.

The Bayeux Tapestry

The Bayeux Tapestry is an embroidery from the 11th century. It is a linen strip 224 feet (68 meters) long and 20 inches (50 centimeters) wide. It recounts the conquest of England by William the Conqueror, Duke of Normandy, who then became king. This exceptional historical document was created between 1066 and 1082 CE. It is on display at the Bayeux Tapestry Museum in Normandy, France.

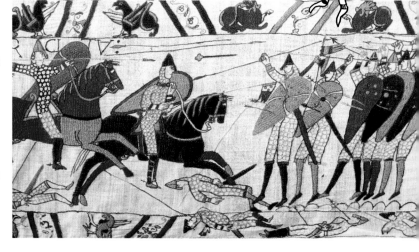

The Church of Conques

The Church of Saint Foy is associated with an abbey at Conques in southern France. Built in 1041, it is a masterpiece of Romanesque art. It is famous for the 12th-century tympanum above its doors and for its treasures from the Carolingian period. At the west entrance of the church, a deep vault shelters the tympanum depicting the Last Judgment: in the center, Jesus rules in majesty with the chosen to his right, in Paradise, and the damned to his left, in Hell.

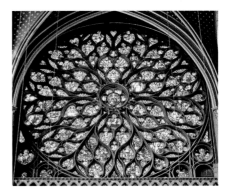

Rose Window of Sainte-Chapelle

The Sainte-Chapelle was built in Paris on the order of King Louis IX, known as Saint Louis, to house relics of Christ that he had acquired beginning in 1239. On the west facade, the great rose window created between 1485 and 1495 illuminates the upper chapel. Thirty feet (9 meters) in diameter, it is in the Flamboyant Gothic style and shows the story of the Apocalypse—the end of the world.

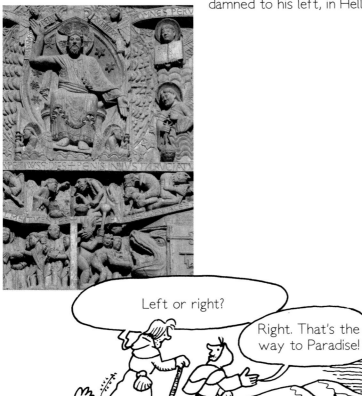

Left or right?

Right. That's the way to Paradise!

Portrait of John the Good

Painted a little before 1350, this portrait is said to show John the Good, future king of France. The profile presentation is inspired by coins. This may be the first portrait of a king of France. Painted in egg tempera over a coat of plaster applied to fine linen, which is glued to an oak panel, it measures 24 inches (60 centimeters) by 17 inches (44 centimeters). It is on exhibit at the Louvre Museum in Paris.

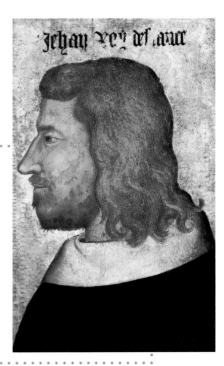

The Art of the Renaissance

Giotto's Frescoes

These scenes belong to a series of frescoes done by the Italian painter Giotto di Bondone in the Scrovegni Chapel (or Arena Chapel) at Padua in Italy. In this Gothic chapel from the beginning of the 14th century, Giotto used luminous and subtle colors, especially blue, in scenes of the life of the Virgin Mary and Jesus from the New Testament. The expressiveness of the figures and their emotionally charged gestures make Giotto the father of Renaissance painting.

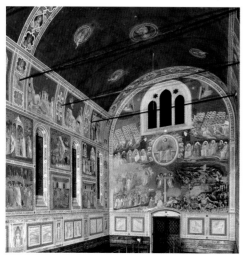

The Very Rich Hours

The Very Rich Hours of the Duke of Berry is a book of prayers commissioned about 1410 by the Duke of Berry from the Limburg brothers of Belgium. It was completed by other artists about 1480. The manuscript contains 66 large miniatures and 65 small ones. The one shown is from the monthly calendar. It can be seen in the library of the Condé Museum in Chantilly, France.

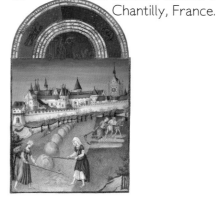

The Arnolfini Portrait

Dated 1434, this work by the Flemish painter Jan van Eyck shows Giovanni Arnolfini, a rich Italian merchant living in Bruges, and his future wife, on the occasion of their marriage. Van Eyck is the first painter to make portraits of men and women from the middle and merchant classes. The painting, 32 by 24 inches (82 by 60 centimeters), is striking for its precision and its light, as well as for its numerous details. The medium is oil paint on wood. It is on exhibit at the National Gallery in London.

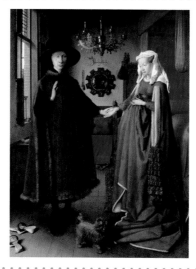

... the Arnolfinis ... AND THEIR DOG!

David

Donatello's *David* is a bronze statue created between 1430 and 1432. Thought to be the first large bronze nude cast since antiquity, it was commissioned by Cosimo de Medici, who at that time ruled Florence. *David* is shown life-size (62 inches / 158 centimeters tall), nude, and in the round—he can be viewed from all sides. His pose is very natural and his body lithe, but his emotions are enigmatic. The statue is on display at the Bargello Palace in Florence.

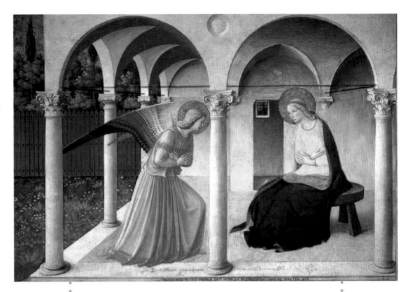

The Annunciation in the Convent of San Marco

This fresco by the monk Guido di Pietro, who was called Fra Angelico, was painted around 1450 at the Convent of San Marco in Florence. It measures 7 by 10.5 feet (216 by 321 centimeters). Fra Angelico combines Renaissance perspective and imitation of reality with colors and symbols inherited from the Middle Ages.

The Birth of Venus

This work by the Florentine painter Sandro Botticelli was created about 1485 and is preserved at the Uffizi Gallery in Florence. The artist, famous for his religious paintings, depicts a scene inspired by Greco-Roman mythology. This Venus emerging from the waters is the first female nude, except for the figure of Eve in religious paintings, since Roman times. It is painted in tempera on a large canvas (5.6 by 9 feet / 172 by 278 centimeters).

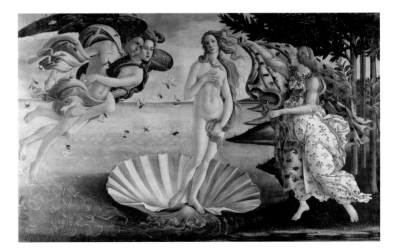

GLOSSARY

Abbey: A place where Christian monks or nuns live. An abbey often consists of a church, a cloister, and living space for the monks or nuns.

Altarpiece: A vertical work, often composed of several parts, located behind the altar in a church.

Basilica: In ancient Rome, a large building used as a market or place of public assembly. It was the model for Christian churches.

Bas-relief: Sculpture in which forms protrude from a flat surface such as a wall.

Cathedral: The church of a bishop, a priest who is in charge of several churches.

Cave art: Paintings or engravings on the walls of caves or rock shelters. Also called parietal art.

Codex (plural, Codices): A group of manuscript pages bound together. It is the forerunner of the book.

Contrapposto: A pose with the body twisted, standing with one leg bent and the other straight.

Fresco: A technique for painting on walls. A fresh coat of plaster is applied, and the artist paints on it before it dries.

Glaze: An almost transparent layer of paint that increases the depth of color.

Iconoclasts: People who oppose, and often destroy, items of religious worship.

Illuminations: Paintings that decorate a manuscript. Often gilding is used to give brightness to the text.

In the round: Said of a sculpture that can be viewed from all sides.

Lapis lazuli: A blue stone used in powder form to create a very luminous blue color.

Patron: A wealthy person who gives money to artists and scholars for their work.

Pigments: Powders that are mixed with a binder and used to make a colored painting.

Pilaster: A column embedded in a wall, with a base and a capital.

Porphyry: A red or green mottled stone.

Relics: The remains of the bodies of saints or martyrs, or objects that belonged to them, which are treated with great veneration.

Scriptorium (plural, Scriptoria): A room, usually in a monastery, where manuscripts were copied.

Stele: A large vertical stone slab, usually bearing an inscription.

Tempera: A water-based paint made with egg.

Trompe l'oeil: Painting that tricks the eye and looks 3-dimensional.

INDEX

Bold page numbers refer to definitions.